To a great friend
Wayne

Peter - Love in Action
THANK YOU!
for Gathering
for Family
Jean

Happy Birthday
to my very
very special
friend
Doris

Happy Birthday
Thank you for
Gathering
Love Bert

Happy Birthday
Live
Love
Laugh
Debbie His

Happy Birthday Starthrune!
"He who knows about the
Great Mystery" May your
caring and understanding
continue bringing you
"Much Joy"
Rovell

Happy Birthday
To someone who has
played a very important
role in my life
Love
Linda

My friend — My friend
Always,
jq

Peter,
Thank you for
being there for most all
of us.
Love,
Dottie

May this year
be filled with love, thanks
for the guidance & direction &
growth & happiness.
I have received from
you
With love,
David Capra

Native Nations

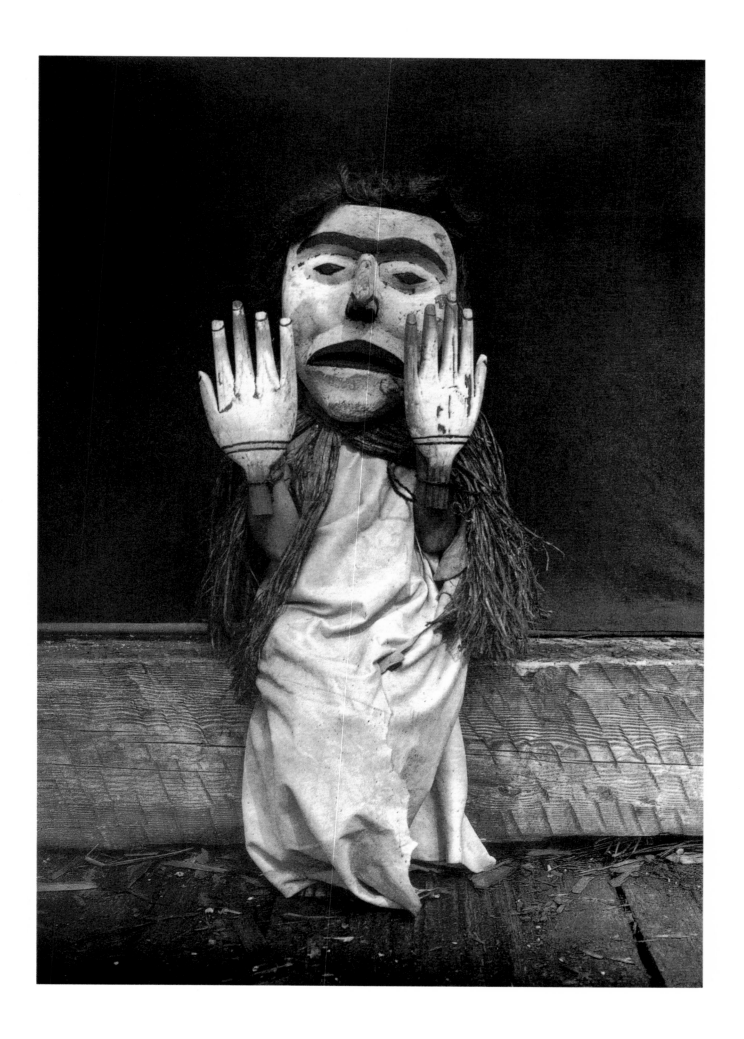

NATIVE NATIONS

First Americans as seen by Edward S.Curtis

Edited by Christopher Cardozo

Foreword by George P. Horse Capture

PRODUCED BY CALLAWAY EDITIONS

A BULFINCH PRESS BOOK
LITTLE, BROWN AND COMPANY

Boston · New York · Toronto · London

FRONTISPIECE: Núḥlimkilaka - Koskimo, 1914
Núḥlimkila (or Núḥlimkilaka, the feminine form) is a forest spirit that causes one to become confused and lose one's way.
The name means "bringer of confusion." The mask is used in the núnḥlim winter ceremony of the Quatsino Sound tribes.

First Edition

ISBN 0-8212-2052-7
Library of Congress Catalog Card Number 93-78491

Bulfinch Press is an imprint and trademark of Little, Brown and Company, Inc.
Published simultaneously in Canada by Little, Brown & Company (Canada) Limited
PRINTED IN THE UNITED STATES OF AMERICA

CONTENTS

EDITOR'S NOTE

I like a man who attempts the impossible.
– J.P. Morgan

Edward Sheriff Curtis achieved the impossible. With *The North American Indian*, he created an irreplaceable photographic and ethnographic record of more than eighty of North America's native nations – a record first published between 1907 and 1930, which, after decades of obscurity in rare book rooms and private collections, is now experiencing its renaissance. Comprising twenty volumes, twenty portfolios, thousands of pages of text, and more than twenty two hundred photogravures, *The North American Indian* remains not only an unparalleled artistic and historic achievement but a watershed in publishing history.

Encouraged by great public hoopla and imbued with blind faith, Curtis did not foresee the unremitting sacrifices the project would exact from him. He hoped to complete the study in five or six years within a budget of $25,000. In fact, what the *New York Herald* hailed as "the most gigantic undertaking since the making of the King James edition of the Bible," required for its completion more than thirty years, one and a half million dollars, and the assistance of a vast array of patrons, researchers, scientists, editors, master craftsmen, interpreters, sympathetic creditors, tribal elders, and medicine men. Ultimately, the study cost Curtis his family, his financial security, and his health. Nevertheless, to the end, he singlemindedly pursued his intense and powerful vision with an extraordinary sense of mission: to catalog how Indians lived prior to their contact with the white man. "The passing of every old man or woman means the passing of some tradition, some knowledge of sacred rites possessed by no other," believed Curtis, "consequently the information that is to be gathered, for the benefit of future generations, respecting the mode of life of one of the great races of mankind, must be collected at once or the opportunity will be lost for all time." His vision was prophetic. By 1930, the year the last volume was published, few visible vestiges remained of the people who had once been the continent's sole inhabitants.

◆ ◆

Born in 1868 near Whitewater, Wisconsin, Edward was the second of Reverend Johnson and Ellen Sheriff Curtis's four children. Reverend Curtis, having returned from the Civil War penniless and too weak to farm, moved the family to Cardova, Minnesota where he often reached his parishioners by canoe, accompanied by five-year-old Edward.

Edward ended his formal education with the sixth grade. But soon thereafter, with a stereopticon lens his father had brought back from the war, and following instructions from the book *Wilson's Photographics* by Edward Wilson on the very new and popular technology of photography, he built his own camera and taught himself to expose and develop film and make pho-

tographic prints. By seventeen, Edward was working as an apprentice photographer in St. Paul. According to Edward's son, Harold, his father would joke that he chose photography because it was easier than cutting wood for a living.

In 1887 Reverend Curtis's health had deteriorated to the point that the family was forced to resettle in the more temperate climate of Puget Sound, near Seattle, Washington. Further weakened by the move, however, he died shortly after their arrival. Edward and his younger brother, Asahel, provided for the family by gathering fruits and vegetables, digging clams, and taking on chores for various neighbors. Despite these hardships, by 1890 Curtis had managed to buy a second camera. Curtis then took a sizable mortgage on his family's homestead to finance a one-half interest in an existing Seattle photographic studio. In 1892, Curtis married Clara Phillips. The couple would eventually have four children: Harold in 1893, Beth in 1896, Florence in 1899, and Katherine in 1909.

It was in the Seattle area that Curtis first encountered Indians whose culture and traditions were still relatively intact. In 1897 Curtis's business expanded to include sales of the photographs of these tribes. To pursue his new interest, he increasingly left to relatives the day to day operation of what was by then the premier photographic and photoengraving studio in Seattle.

In 1898 a chance event radically altered the direction of Curtis's life. During an extended season spent photographing on Mount Rainier, Curtis rescued a group of lost mountaineers. The party included several members who were nationally recognized for their work in the areas of conservation, Indian ethnography, and publishing, among them, head of forestry, Gifford Pinchot, chief of the U.S. Biological Survey, C. Hart Merriman, and naturalist, conservationist, and renowned Indian authority, George Bird Grinnell. Not only were they grateful, several became interested in Curtis's photographic work. These contacts led to appointments to two important photographic expeditions. On the second of these expeditions, in 1900, Grinnell took Curtis to live among, and photograph, Indians in Montana and instructed him in the systematic methods required for gathering scientifically valid information. Only weeks after his experiences with Grinnell, Curtis initiated his own expedition to photograph Indians in the southwest.

In the field, Curtis instituted his own methodology, "the twenty-five cardinal points," to amass information on all areas of Indian life and lore, including vocabulary, political and social organization, religious customs, dwellings, food gathering and preparation, geography, games, music and dance, dress, weights and measures, and marriage, death, and birth customs. While Curtis was able to gather significant data on all these subjects, his most important contribution was in the areas of mythology and spirituality, fields in which many others had previously failed to gather information.

Curtis often sent assistants ahead months in advance to supplement his extensive pre-field research. Only when Curtis felt sufficiently briefed by both his many assistants, led by W.E. Myers, and the leading Indian scholars, did he begin the actual field work. This depth of understanding was critical to his success. Equally critical was the rapport he established with tribal members. Upon meeting Curtis, "their armor of hostility seemed to slowly dissolve before my eyes," wrote his daughter, Florence Curtis Graybill. "They were looking at a man who understood and cared. They felt the warmth of his friendship, and in turn he was their friend."

"If I find a man who won't talk . . . I have a way which seldom fails," expanded Curtis. "I make some theological error. It irritates him. 'Why, that isn't so,' he blurts out; and before he knows it, he is telling me why it isn't so and going on to other points in his creed." To gather as much information as he could, Curtis also participated as closely as possible in the daily life of the various tribes. "He is just like us," an elder is quoted as saying, further allowing, "he knows about the Great Mystery."

"Word passes from tribe to tribe," added Curtis who was soon dubbed the "shadow-catcher." "A tribe that I have visited and studied lets another tribe know that after the present generation has passed away men will know from this record what they were like, and what they did, and the second tribe doesn't want to be left out. Tribes that I won't reach for four or five years yet have sent word asking me to come and see them There was old Black Eagle, an Assiniboin, ninety years old, who had all of his life refused to talk about his nation to white men. At last he became convinced that his tribe ought to get into the record, and he unbent, and he gave me a great amount of valuable information."

<p style="text-align:center;">♦ ♦</p>

Curtis's activities between 1901 and 1903 are not well documented, but by 1904, his Indian pictures eclipsed in significance all his other work. Popular attitudes were shifting towards an interest in Native American culture, and Curtis began to give formal lectures and hold exhibitions of his Indian photographs. His work received wide exposure in national magazines, and articles by and about Curtis began to appear across the country as well. He soon hired a publicist to help sell his work internationally.

While he enjoyed great celebrity, his activities were not self-sustaining, and he was forced to borrow substantial sums to survive. Fortunately, among Curtis's many friends and allies was President Theodore Roosevelt who provided Curtis with a letter of introduction to J. P. Morgan. Then one of the most powerful men in the world, Morgan was also a renowned bibliophile very active in producing elegant limited edition books on his various collections.

At their meeting, Morgan summarily dismissed Curtis saying he could not take on any more commitments. Undaunted, Curtis asked that Morgan at least look at his photographs. Upon seeing the work, the usually intransigent Morgan agreed to commit $15,000 a year for five years. In exchange, Morgan was to receive twenty-five sets of books and portfolios, as well as five hundred original photographs.

Curtis and Morgan decided the sets would only be offered to the public by subscription. The cost was $3,000 per set, and neither the books nor the portfolios could be purchased separately. The binding was of high-grade buckram and expensive, hand-tooled Moroccan leather. The books had top-edge gilding, raised spines, and fine gold lettering. Curtis chose photogravure as his preferred printing medium. A type of etching, photogravure was a highly respected method for making original photographic prints, especially when the prints were to be made in multiples. The process was widely utilized by a number of photographers, including the most influential art photographer of the time, Alfred Stieglitz. The process was prized for its ability to

render great subtlety of tone and fineness of resolution. Because this was an ink-transfer process, the prints could be made directly on the etching stock, which could then go directly into the book as individual pages. Photogravure provided Curtis with a range of color possibilities, and he chose sepia, a color consistent with his toned black and white prints. The text was printed either on vellum or Van Gelder, while the photogravures were reproduced on these as well as India Proof "tissue" etching stock. The tissue prints were exceedingly thin and had to be tipped onto a support paper before being bound into the books or included in the portfolios. Curtis charged nearly a thirty percent premium to the handful of subscribers who opted for tissue sets, among them J.P. Morgan for his personal set, set number one.

When Curtis and Morgan struck their deal, both men assumed a major publisher would take over the risks and responsibilities of publishing such a monumental project, leaving Curtis free to concentrate on the photography and ethnography. Unfortunately, publishing houses shied away from such an ambitious and capital-intensive undertaking, so Curtis agreed also to become chief administrator, fund raiser, and publisher. This was an enormous, backbreaking task. The substantial costs and demands of being in the field with assistants, interpreters, film and still cameras, and sound recording equipment paled in comparison to the cost of making the photogravure plates, pulling the limited edition prints, and binding the books and portfolios. Each of these steps required more capital than all the field research combined. Curtis was forced to devote ever increasing amounts of time to fundraising and publishing burdens, which greatly distracted him.

By the end of 1908, Volumes 1 and 2 were completed. But the financial panic of 1907 had seriously impaired his sales efforts, and he managed to place far fewer than the five hundred sets thought necessary to make the project profitable. In fact, as late as 1930 Curtis had only managed to secure two hundred subscribers. His herculean efforts to interest prospective purchasers were further hampered by a world war, dwindling interest in Native Americans, and, perhaps most importantly, the widely held misperception that J.P. Morgan would pick up the financial slack whenever necessary. The lack of subscriptions created significant hardships not only for the project, but also for Curtis, personally, who worked for years on *The North American Indian* without drawing a salary. Completion of the project was probably delayed for over a decade due to inadequate funding. These financial difficulties took a heavy toll on Curtis.

In addition, he took on the daunting task of creating ten thousand Edison wax cylinder recordings of Indian language and music. The delicate wax cylinders were often rendered unusable by heat, dirt, excessive moisture, or a variety of other factors almost impossible to control in the field. Much of the information he was able to record was incorporated into the volumes. Many of the recordings still survive at the University of Indiana archives. They provide an invaluable record, particularly for Native Americans, as they may be the only extant record of lost language, music, or family histories.

While Curtis completed the first eight volumes and portfolios in only five years, it would take him nearly twenty years to complete the remaining twelve volumes and portfolios. The first eight concentrated on tribal groups of the Southwest, the Northern Plains, and the Plateau. Curtis's three Northwest Coast volumes (9, 10, and 11) were published between 1913 and 1916,

but it was not until 1922 that Volume 12 on the Hopi appeared. Like many other volumes, Volume 12 contained information and photographs from a number of field trips. In this case, many trips, going back to 1900, were incorporated in a single volume. Volumes 13, 14, and 15 on the California tribes were published in short order, followed by two volumes on the New Mexican Pueblos. Soon after, the volume on the northern Woodlands as well as the volume on the tribes forced out of their homelands into Oklahoma were finished. Finally, the last volume, 20, comprising work on the Alaskan Eskimo, was published in 1930.

Unfortunately, because of the expense, rarity, and inaccessibility of *The North American Indian*, much of Curtis's work was forgotten even before the project was completed. Having driven himself to the limit for thirty years, Curtis suffered a nervous and physical breakdown, and his whereabouts for the next two years are unknown. Upon his recovery, Curtis resumed some of his activities as a photographer and did film work in Hollywood. Yet, despite great physical disabilities and hardships, he never lost his intellectual drive and curiosity. As late as 1949, in his early eighties, he was deeply involved in researching his new passion and hoped to write a book entitled, "The Lure of Gold." In 1950 he had even planned to join a major gold mining expedition to Brazil and the wild regions of the Amazon and the Andes. Unfortunately, the organizers of the expedition had a falling-out and the expedition was cancelled. Curtis was crushed, a visit to the Amazon having been a life-long interest. Curtis's physical condition further deteriorated and in the fall of 1952, at the age of eighty-four, he died of a heart attack. In its seventy-six word obituary, *The New York Times* noted in passing that Curtis had been a photographer.

◆　　　◆

I have selected for inclusion here what I consider to be among the best of Curtis's images. Excerpts from Curtis's original text accompany the photographs.

Christopher Cardozo
Minneapolis, Minnesota
1993

ROOSEVELT ON CURTIS

In Mr. Curtis we have both an artist and a trained observer, whose pictures are pictures, not merely photographs; whose work has far more than mere accuracy, because it is truthful. All serious students are to be congratulated because he is putting his work in permanent form; for our generation offers the last chance for doing what Mr. Curtis has done. The Indian as he has hitherto been is on the point of passing away. His life has been lived under conditions thru which our own race past so many ages ago that not a vestige of their memory remains. It would be a veritable calamity if a vivid and truthful record of these conditions were not kept. No one man alone could preserve such a record in complete form. Others have worked in the past, and are working in the present, to preserve parts of the record; but Mr. Curtis, because of the singular combination of qualities with which he has been blest, and because of his extraordinary success in making and using his opportunities, has been able to do what no other man has ever done; what, as far as we can see, no other man could do. He is an artist who works out of doors and not in the closet. He is a close observer, whose qualities of mind and body fit him to make his observations out in the field, surrounded by the wild life he commemorates. He has lived on intimate terms with many different tribes of the mountains and the plains. He knows them as they hunt, as they travel, as they go about their various avocations on the march and in the camp. He knows their medicine men and sorcerers, their chiefs and warriors, their young men and maidens. He has not only seen their vigorous outward existence, but has caught glimpses, such as few white men ever catch, into that strange spiritual and mental life of theirs; from whose innermost recesses all white men are forever barred. Mr. Curtis in publishing this book is rendering a real and great service; a service not only to our own people, but to the world of scholarship everywhere.

Theodore Roosevelt
October 1, 1906

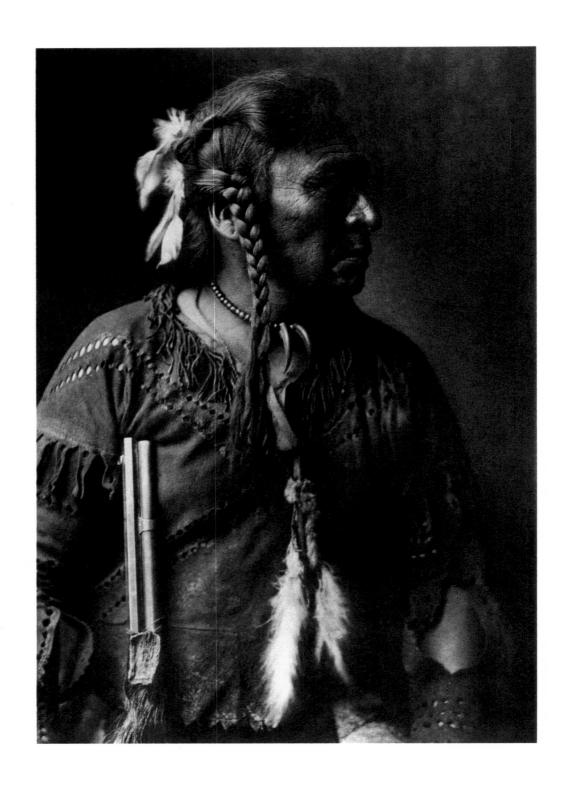

HORSE CAPTURE (WAÁTYÁNATH) · ATSINA, 1908

Born near Milk River, Montana, in 1858. When about fifteen years of age he went with a war party against the Piegan, but achieved no honor. From their camp at Beaver Creek the Atsina sent an old man out as a decoy. When the Sioux charged him, the rest of the Atsina rushed out and killed them both. During the fight, Horse Capture ran up to one of the enemy, who was wounded, in order to count coup, when one of his companions dashed ahead of him and was killed by the wounded Sioux. Horse Capture then counted first coup on the enemy and killed him. He married at the age of twenty-five. His tribe, the Atsina, commonly designated Gros Ventres of the Prairie, are of the Algonquian stock and a branch of the Arapaho. Their name for themselves is Aáninen, Atsina being their Blackfoot name.

FOREWORD

Moving northward in my trusty Indian Bronco, we traverse through swarms of winter snow snakes as they wind their icy way across the lonely ribbon of asphalt. Rising above the first big wheat field on the right is an unplowed knoll, crowned with native prairie grass and a small pile of stones. A great tribal leader lies buried beneath this bit of earth. He is my great-grandfather, Horse Capture. He passed from this place sixty-nine years ago, after enjoying sixty-six summers. I first met him face-to-face in 1969 in a photographic likeness, a lasting legacy retained by the preeminent recorder of the Indian West – Edward S. Curtis.

As we pass the stubbled wheatfield, memories of my dark days – my childhood on the reservation – come easily, but now seem far away in time and space, and I am reminded once again of our history and of the importance of my great-grandfather. His presence in our lives, symbolizing all of our American Indian elders, ushered in light and knowledge where there was only darkness before.

Growing up on an Indian reservation is not as romantic and full of adventure as some might believe. As shaggy-headed children we played all day long, climbing trees, swimming in the murky Milk River, picking berries and doing most of the things that country kids everywhere do. We played in the sunshine, oblivious to our poverty and low social status. When we entered the off-reservation public school, our environment abruptly changed as we encountered the non-Indian world for the first time. As we studied our lessons, it soon became apparent to us that this culture ignored Indian people. Only George Washington, Thomas Jefferson, George Armstrong Custer, and other non-Indians filled the history books. Even Jesus was white. It was as if we didn't exist, and our minds and souls suffered from this exclusion in our own country.

We learned that there are several ways to survive in the world and that Indian people have explored all of them. We can allow ourselves to be assimilated into the general population, to forget the Indian world and to live far away, but in the long run, this course is generally not successful. Or, we can stay home on the reservation and live as best we can, working for the federal government, the Bureau of Indian Affairs, or the tribal government. For some, this is a good way to help our people. However, after a certain amount of time is spent with these organizations, idealism and dedication become less important than thoughts of retirement benefits, and community-oriented effectiveness is limited.

Another method of coping is hatred, directed at everyone who harmed our people, yesterday and today. Now, many non-Indians say, "I had nothing to do with the injustices of the past, so I have no responsibility for today." Indians realize that this is not true, because the injustices of long ago extend to today. Contemporary struggles against injustice encompass a desire for educational curricula that include Indian studies as well as the protection of our water, land, timber, treaty rights, and every other thing of value to us. Perhaps it is understandable for some

to take the course of hatred. We have few other sources of political power, and hatred can give strength and can serve to unite us. Whether it is effective or not will take time to determine.

Religion is another way of coping. U.S. government policy and Christianity severely damaged our religious traditions, and few effective substitutes were offered as replacements. Today, the revival and practice of old ways is a growing trend in the Indian population. Our buttes and Sun Dance lodges are once again filling with vision quests and traditional prayers, as our people return to the ways of their ancestors.

Life continued for the fortunate ones of us who, saddled with inferiority complexes, survived the public school system. We endured the racism heaped upon us by the white citizenry and their progeny, and many other corrosive factors. But the sun had left our world, and we walked in shadow, ashamed of ourselves without knowing the reason.

Against all odds, some of us made it to college, and a whole new universe opened for us. Higher education may be the ultimate way to deal with racism. In addition to discovering the wider world, we also learned more about ourselves. Happily, we selected courses that met our needs and related somehow to our Indian world.

Searching for information on my tribe became my major objective as there was no cultural information available at home. The reams of tribal data piled up, and each new research discovery set an informational precedent. While in pursuit of a tribal dictionary compiled by an early Jesuit missionary, I made a visit to the order's archives at Gonzaga University in Spokane. Father Schoenberg said, "Come with me. I want to show you something." After passing through many corridors and doors, we came to a large file in a remote section of the archives. Opening a drawer, the priest carefully removed an immense sepia-toned photographic print. He held it out to me, saying, "This must be your relative." And there, in that hidden place, for the first time, I saw Horse Capture, my great-grandfather.

The world stopped for several moments as I peered at my direct blood ancestor. He was handsome and strong. His classic tribal hairstyle, clothing, and proud bearing marked him as a leader of the A'ani. He was free from restricting complexes; his moccasins were firmly planted on the earth.

This was the moment when my great-grandfather and I met for the first time, across the ages. Scanning the treasured photogravure, I saw in the left corner, next to my great-grandfather's English and Indian names, the word Atsina, a derogatory and incorrect term used to designate our tribe. In the center, smaller printing spelled out the name of the photographer: E.S. Curtis. So, at the very time I met my great-grandfather, I also met Edward Curtis, and they both have been with me ever since.

The series contained other images of prominent leaders of our tribe. I had only known them through historical texts, and now I thought, "So that's what you look like." We have legends of many of these great men, but we had never actually seen them. The Curtis images record their beauty and power, and no more will we have to deal with abstract words to describe them. They are here in all their glory and I was so grateful to be in their presence. As I stood there, my chest began to swell with a new and strange feeling. For the first time, I felt fierce pride at being an Indian, an A'ani.

In a sense, finding the E.S. Curtis Horse Capture photograph was the pinnacle of my life-long search. But my search continued because the more knowledge we obtain about ourselves the better. Our children don't have to face the same dark road we had to travel. Instead, the prospect of the bright light of knowledge and confidence entered our lives.

My immediate goal became studying the works of E.S. Curtis, specifically his monumental work, *The North American Indian*. The results exceeded my dreams and increased my admiration for the man and his dedication. Most major endeavors are based on financial gain, but he persevered even when it meant bankruptcy, and the depth and detail of Curtis's study reveals that he went far beyond the limits of mere "work."

⋆　　　⋆

The impressive visuals portray the American Indian at his classical best. As an enhancement, brief biographies list the Indian name and a short history of each subject. Taking full advantage of his situation, Curtis also utilized the latest recording device of his time, the wax cylinder recording machine. In so doing, he added another dimension to the historical and cultural information on each tribe, by recording and preserving tribal songs performed by the leaders of the time. These recordings are housed at the University of Indiana at Bloomington. Listening to these scratchy but special songs, a tribal scholar is sometimes able to determine the identity of the singer. Looking at the image of the singer and listening to him sing a song recorded nearly one hundred years ago produces an intimate and almost eerie bond, uniting the two worlds. In many cases, the data in *The North American Indian* can be found nowhere else. Curtis's work is a primary source.

Strengthened and armed by the confidence instilled in us by the works of E.S. Curtis and a few others, many of us moved beyond our previous restrictions and became successes in the professions or other chosen fields. We discovered monographs, articles, books, and the Curtis photographs, and they confirmed what we had known all along. We set forth, each in our own way, to use this new knowledge to help overcome the perennial racism that infests our country.

As appreciative as I am of Curtis and his work, I must place him into a proper perspective. When one admires the many books and haunting visuals of this photographer, one is generally awestruck by the beauty of the images, as well as by the dedication and persistence of the photographer. When one considers the difficulties he had to overcome — transportation, establishing a rapport with the tribes, photographic processing techniques in the field, printing techniques and all the rest — he earns our admiration.

However, there is an essential element usually missing from this praise: the importance of his subjects. The ultimate beauty of *The North American Indian* lies not only with the photographic genius of E.S. Curtis, but also and perhaps most importantly within his subjects. The native beauty, strength, pride, honor, dignity and other characteristics may have been captured by photographic techniques, but they were first an essential part of the people. While Curtis was a master technician, the Indians possessed the beauty. Curtis, as talented as he was, did not contribute to the exhaustion of Red Cloud, the strength of Chief Joseph, the courage of Bear's Belly, nor the

quiet dignity of Horse Capture. All he could do was highlight and document them on film. But we are thankful for his record.

• •

Solemnity and tension did not mark all of the racial struggles we encountered; humor and patience often held the key to our success. Teachers in our distant off-reservation schools had a tendency to notice Indian students only at Thanksgiving. When the national holiday rolled around, they would call on me, usually the only Indian, and would ask me to come up to the front of the room. Startled from my sanctuary at the back, I was suddenly thrust into the center ring. The teacher explained that I was to talk on the Indians, the Pilgrims, and Squanto. I never really knew who Squanto was, but later heard he was an East Coast Indian who had helped the Pilgrims in some way and had become a hero for them. I stumbled to the front of the classroom, where with great embarrassment I tried to think of something to say. Guided by the teacher's leading questions, I somehow survived what seemed to be an eternity of unfamiliar and unwanted exposure. After the presentation, I scurried back to my seat and took refuge there for the remainder of the year.

As a successful adult, I believed these humiliating days were part of my dark past, but while living in California many years later, my young children began to complain that they dreaded Thanksgiving for the same reasons that had previously haunted me. Remembering my youth, I realized that the teacher and others like her were not really cruel, they were just ignorant about Indians, and perhaps even thought they were doing some kind of service by calling attention to their notion of the Indian role in Thanksgiving. As I pondered how to react to my children's situation, my great-grandfather came to mind and a plan emerged.

Sure enough, when the holiday arrived, the teacher called my son to the front of the room to talk about Indians and Pilgrims, but this time, we were prepared. Clutching a photograph, he bravely stood in front of his classmates and said that on Thanksgiving Day we give thanks for our lives and for all we have. Such a day is unique and special, he said, and explained that the custom descends from the first such holiday that took place long ago, when the Pilgrims celebrated their survival with the assistance of the Indian people.

Taking the Curtis print off the table, he held it aloft for his classmates to see. "This man," my son continued, "was a buffalo Indian, a warrior, who went on a war path and received honors. He undertook successful vision quests and was so respected that the tribe chose him to be the last Keeper of our Sacred Flat Pipe, the most sacred object in our world. This is my relative."

Peering at the barrel of the rifle, he pointed to something hanging there and said, "Do you see this item? This is a scalp won in battle by Horse Capture and it represents your relative." Wearing a happy grin on his face, he marched back to his seat amid total silence. The next year around the holiday we were prepared once again, but apparently the word had spread and no Indian speeches were scheduled.

It is universally acknowledged that the Indian photographs taken by Curtis are classics in every sense. They appear in various forms everywhere. When a museum exhibit or publication

features them, they always produce comment. Several "Indian" individuals have viewed Curtis and his works critically, remarking that the images continue a stereotype. To me, such comments say more about the critics than about the photographer.

One of Curtis's major goals was to record the Indian people's images and to make a picture of the culture of their time. Not content to deal only with the current population, their arts and industries, he recognized that the present is a result of the past, and the past dimension must be included. Guided by this concept, Curtis recorded the songs that had been sung by his subjects in the past, as well as their myths, legends, and other historical tribal foundations, all from a past tradition. Extending the same principle to the photographs, he presented his subjects in a traditional way whenever possible and even supplied a shirt when his subject had none. Reenactments of battles, moving camp, and other past activities were preserved as well. I am sure this effort provided extended pleasure to these elders. And it continues today to bring us closer to our traditional people and history.

The only photograph hanging in our tribal council chambers is of a tribal member taken by E.S. Curtis. Another likeness from the same source adorns a community park. These images are of our people and they are close to us. Their detractors are foreign and do not speak for us. These "Indian" critics lack a genetic or geographical connection with us and cannot represent us. Real Indian people are extremely grateful to see what their ancestors looked like or what they did and we know they are not stereotypes. No one staged the people. And we see them at their classic finest.

A sense of continuity emerges from our familiarity with the people of the Curtis portraits and our knowledge of the Indian people who live on reservations in our region today. With a photographer's perceptive eye, perhaps Curtis selected only the most striking and representative members of the groups he encountered, but he may have seen in many a quality of leadership. A surprisingly large number of current Indian leaders are direct descendants of those who were photographed by Curtis.

As I near the end of my journey, the sun is bright, flooding the world with warmth and light. Blossoms are everywhere. It is a great honor to be asked to write this introduction. For me to be invited to do so while I live on a remote Indian reservation in Northern Montana is quite remarkable and hopefully precedent-setting. In addition to my having the opportunity to give a reservation view of the Curtis works, other wonderful associated undertakings and events will be part of this project. I will present fifty copies of this book to fifty Indian high schools and colleges. Several full page, loose-leaf, unbound tribal portraits will accompany each of the fifty books. They can adorn tribal libraries and classrooms.

I thank the publisher, Callaway Editions and Mr. Cardozo for including the Indian people in this project and for their gifts to our children. May they walk in sunshine.

George P. Horse Capture
Fort Belknap Indian Reservation
Montana, 1993

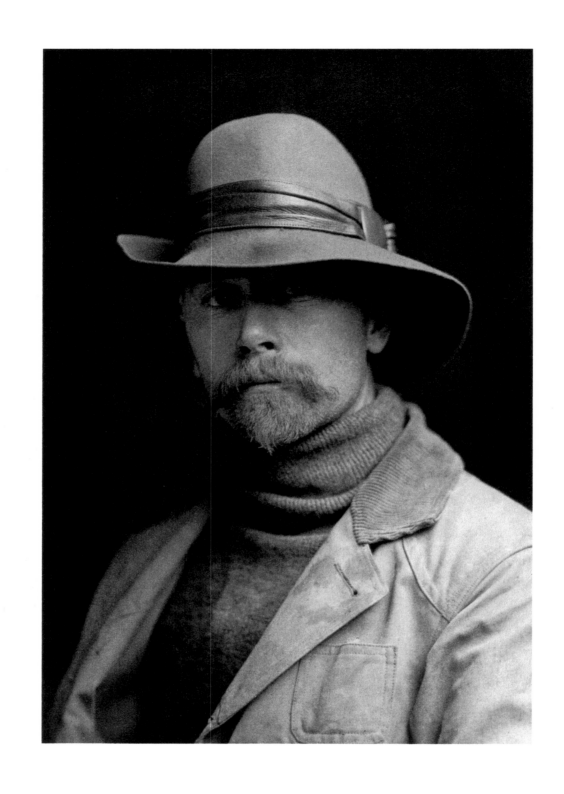

SELF PORTRAIT, 1899

INTRODUCTION

The task of recording the descriptive material embodied in this volume, and of preparing the photographs which accompany them, had its inception in 1898. Since that time, during each year, months of arduous labor were spent in accumulating the data necessary to form a comprehensive and permanent record of all the important tribes of the United States and Alaska.

It has been the aim to picture all features of the Indian life and environment – types of the young and the old, with their habitations, industries, ceremonies, games, and everyday customs. Rather than being designed for mere embellishment, the photographs are each an illustration of an Indian character or of some vital phase in his existence. Yet the fact that the Indian and his surroundings lend themselves to artistic treatment has not been lost sight of, for in his country one may treat limitless subjects of an aesthetic character without in any way doing injustice to scientific accuracy or neglecting the homelier phases of aboriginal life. Indeed, in a work of this sort, to overlook those marvellous touches that Nature has given to the Indian country, and for the origin of which the native ever has a wonder-tale to relate, would be to neglect a most important chapter in the story of an environment that made the Indian much of what he is. Therefore, being directly from Nature, the accompanying pictures show what actually existed, not what the artist in his studio may presume the Indian and his surroundings to be.

The task has not been an easy one, for although lightened at times by the readiness of the Indians to impart their knowledge, it more often required days and weeks of patient endeavor before my assistants and I succeeded in overcoming the deep-rooted superstition, conservatism, and secretiveness of the Indian people. Once the confidence of the Indians was gained, the way led gradually through the difficulties, but long and serious study was necessary before knowledge of the esoteric rites and ceremonies could be gleaned.

At times the undertaking was made congenial by our surroundings in beautiful mountain wild, in the depths of primeval forest, in the refreshing shade of cañon wall, or in the homes and sacred places of the Indians themselves; while at others the broiling desert sun, the sand-storm, the flood, the biting blast of winter, lent anything but pleasure to the task.

The word-story of this primitive life, like the pictures, must be drawn direct from Nature. Nature tells the story, and in Nature's simple words I can but place it before the reader. In great measure it must be written as these lines are – while I am in close touch with the Indian life.

It is near to Nature that much of the life of the Indian still is; hence its story, rather than being replete with statistics of commercial conquests, is a record of the Indian's relations with and his dependence on the phenomena of the universe – the trees and shrubs, the sun and stars, the lightning and rain – for these to him are animate creatures. Even more than that, they are deified, therefore are revered and propitiated, since upon them man must depend for his well-being.

While primarily a photographer, I do not see or think photographically; hence the story of Indian life will not be told in microscopic detail, but rather will be presented as a broad and luminous picture. And I hope that while our extended observations among these people have given no shallow insight into their life and thought, neither the pictures nor the descriptive matter will be found lacking in popular interest.

Though the treatment accorded the Indians by those who lay claim to civilization and Christianity has in many cases been worse than criminal, a rehearsal of these wrongs does not properly find a place here. Whenever it may be necessary to refer to some of the unfortunate relations that have existed between the Indians and the white race, it will be done in that unbiased manner becoming the student of history. As a body politic recognizing no individual ownership of lands, each Indian tribe naturally resented encroachment by another race, and found it impossible to relinquish without a struggle that which belonged to their people from time immemorial. On the other hand, the white man whose very own may have been killed or captured by a party of hostiles forced to the warpath by the machinations of some unscrupulous government employee, can see nothing that is good in the Indian. There are thus two sides to the story, and such questions must be treated with impartiality.

Nor is it our purpose to theorize on the origin of the Indian – a problem that has already resulted in the writing of a small library, and still with no satisfactory solution. The object of the work is to record by word and picture what the Indian is, not whence he came. Even with this in view the years of a single life are insufficient for the task of creating in minute detail all the intricacies of the social structure and the arts and beliefs of many tribes. Nevertheless, by reaching beneath the surface through a study of his creation myths, his legends and folklore, more than a fair impression of the mode of thought of the Indian can be gained. In each instance all such material has been gathered by the writer and his assistants from the Indians direct, and confirmed, so far as is possible, through repetition by other members of their tribe.

Ever since the days of Columbus the assertion has been made repeatedly that the Indian has no religion and no code of ethics, chiefly for the reason that in his primitive states he recognizes no supreme God. Yet the fact remains that no people have a more elaborate religious system than our aborigines, and none are more devout in the performance of the duties connected therewith. There is scarcely an act in the Indian's life that does not involve some ceremonial performance or is not in itself a religious act, sometimes so complicated that much time and study are required to grasp even a part of its real meaning, for his myriad deities must all be propitiated lest some dire disaster befall him.

Likewise with their arts, which casual observers have sometimes denied the Indians; yet, to note a single example, the so-called "Digger" Indians, who have been characterized as in most respects the lowest type of all our tribes, are makers of delicately woven baskets, embellished with symbolic designs and so beautiful in form as to be works of art in themselves.

The great changes in practically every phase of the Indian's life that have taken place, especially within recent years, have been such that had the time for collecting much of the material, both descriptive and illustrative, herein recorded, been delayed, it would have been lost forever. The passing of every old man or woman means the passing of some tradition, some

knowledge of sacred rites possessed by no other; consequently the information that is to be gathered, for the benefit of future generations, respecting the mode of life of one of the great races of mankind, must be collected at once or the opportunity will be lost for all time. It is this need that has inspired the present task.

I take this opportunity to express my deep appreciation to those who have so generously lent encouragement during these years of my labor, from the humblest dwellers in frontier cabins to the captains of industry in our great commercial centres, and from the representatives of the most modest institutions of learning to those whose fame is worldwide. Without this encouragement the work could not have been accomplished. When the last opportunity for study of the living tribes shall have passed with the Indians themselves, and the day cannot be far off, my generous friends may then feel that they have aided in a work the results of which, let it be hoped, will grow more valuable as time goes on.

Edward S. Curtis
1906

PLATES

MÓSA - MOHAVE, 1903

It would be difficult to conceive of a more thorough aboriginal than this Mohave girl. Her eyes are those of a fawn of the forest, questioning the strange things of civilization upon which it gazes for the first time. The Mohave home is on the banks of the Colorado River, an environment into which they have so fitted themselves that they seem to have been always a vital part of it.

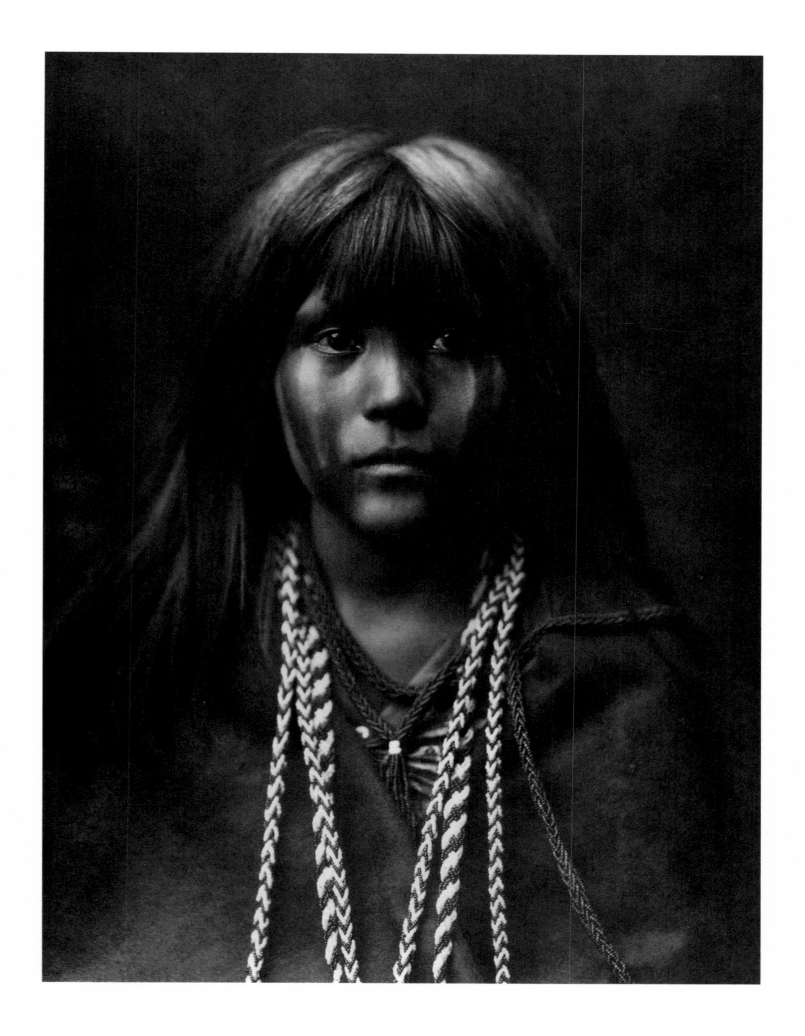

TYPICAL NEZ PERCÉ - NEZ PERCÉ, 1899

The Nez Percés, a loosely associated group of local bands, each possessing its own territory and its own chief, are among the best known Indian groups. Intellectually, culturally, and physically they were the leaders among the indigenous peoples of the Columbia River basin, and made a marked impression on explorers, traders, missionaries, and army officers. From the day they were first seen by Lewis and Clark in 1805 to the close of the Nez Percé War in 1877, those who were brought into contact with them found them to be exceptional people.

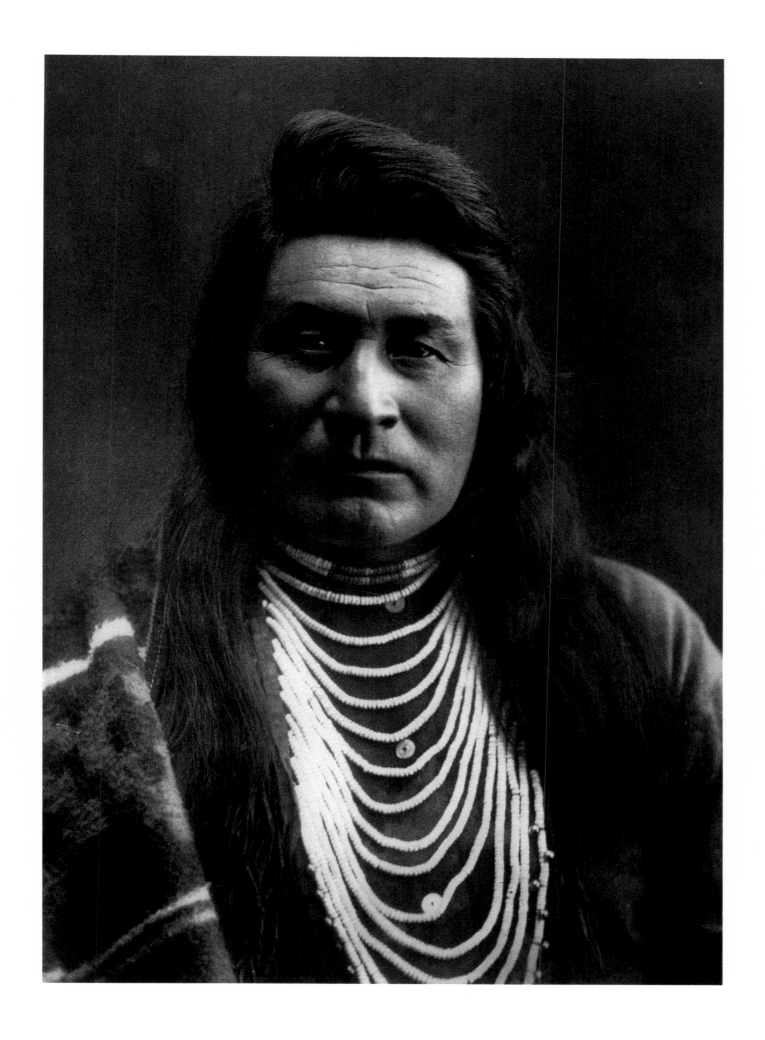

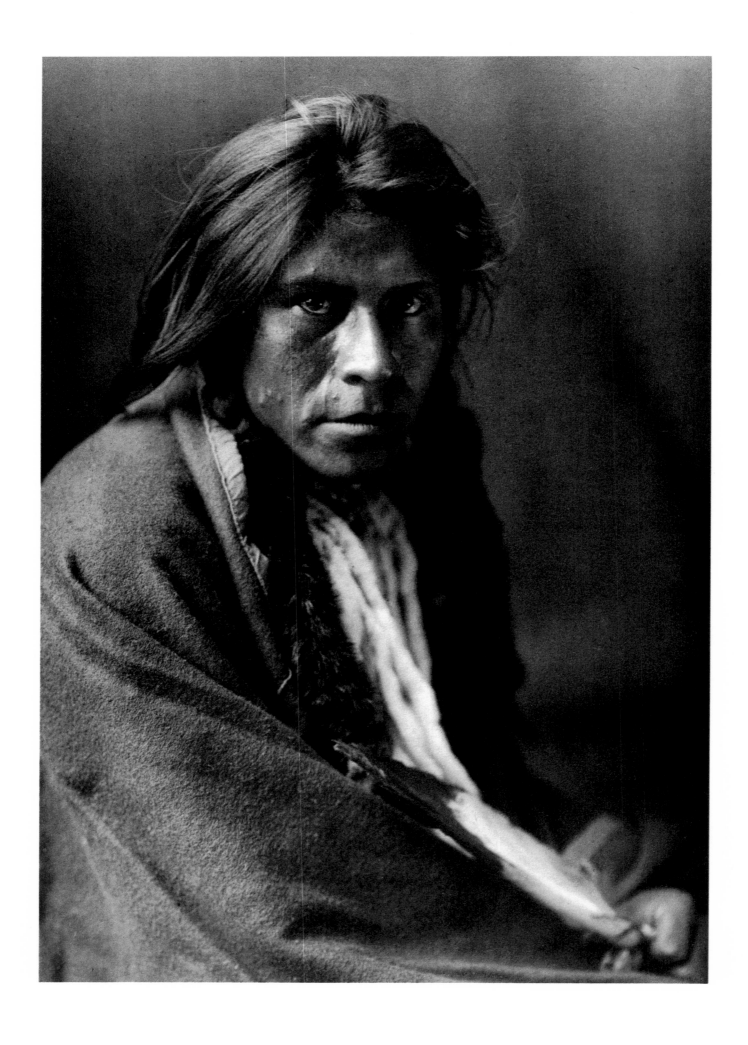

KALISPEL TYPE - KALISPEL, 1910

The Kalispel live in northeastern Washington, in the valley of Clarks Fort of the Columbia River, from about the place where the Idaho boundary crosses the stream down to Box Cañon. In the summer, they assemble in their picturesque village, consisting of a few wooden houses and a dozen or more canvas-covered tipis. Though not addicted to war, the Kalispel are reckless fighters when aroused. In the buffalo plains there were frequent encounters with Blackfeet, Apsaroke, and Sioux. Many of their horses were obtained by raids into the territory of the Coeur d'Alenes, the Nez Percés, and the Yakima, and they were at enmity also with the Kutenai, who sometimes invaded their country for horses. It was from the Flatheads that they acquired the custom of scalping. The tribe includes not more than a hundred persons, whose cabins here and there dot the valley on the eastern side of the river for a distance of some fifteen miles southward from Mission Creek.

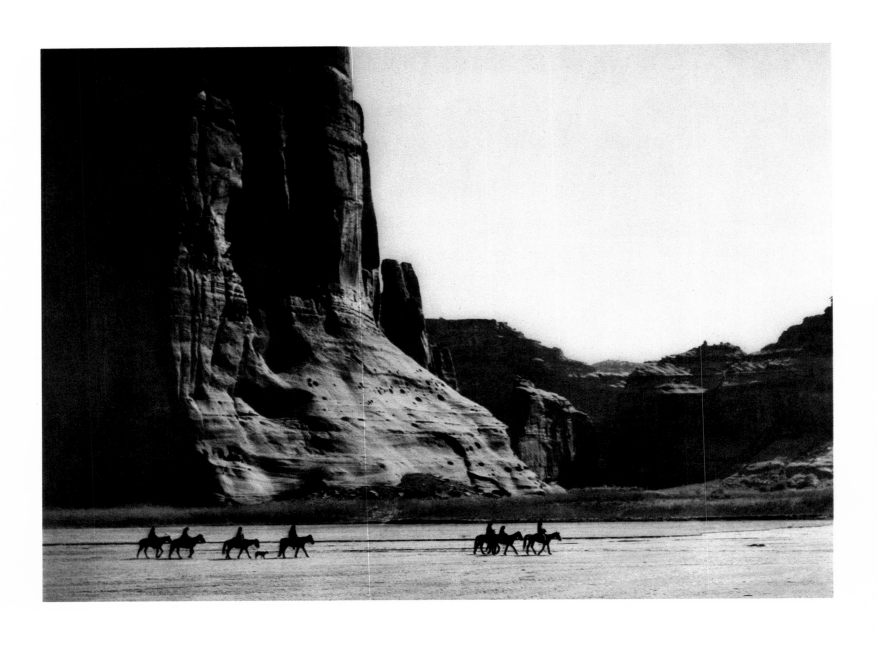

CAÑON DE CHELLY, ARIZONA - NAVAHO, 1904

In the heart of Navaho country, this spot exhibits evidence of having been occupied by a considerable number of people. Every niche on every side contains the cliff-perched ruins of former villages. Termed the garden spot of the reservation, there had been diminutive farms and splendid peach orchards irrigated with freshet water. The cañon drains an extensive region, and even a light rain causes the stream which flows at the base of its lofty walls to become swollen. This water natives diverted to their miniature cornfields and orchards, one or two freshets assuring good crops.

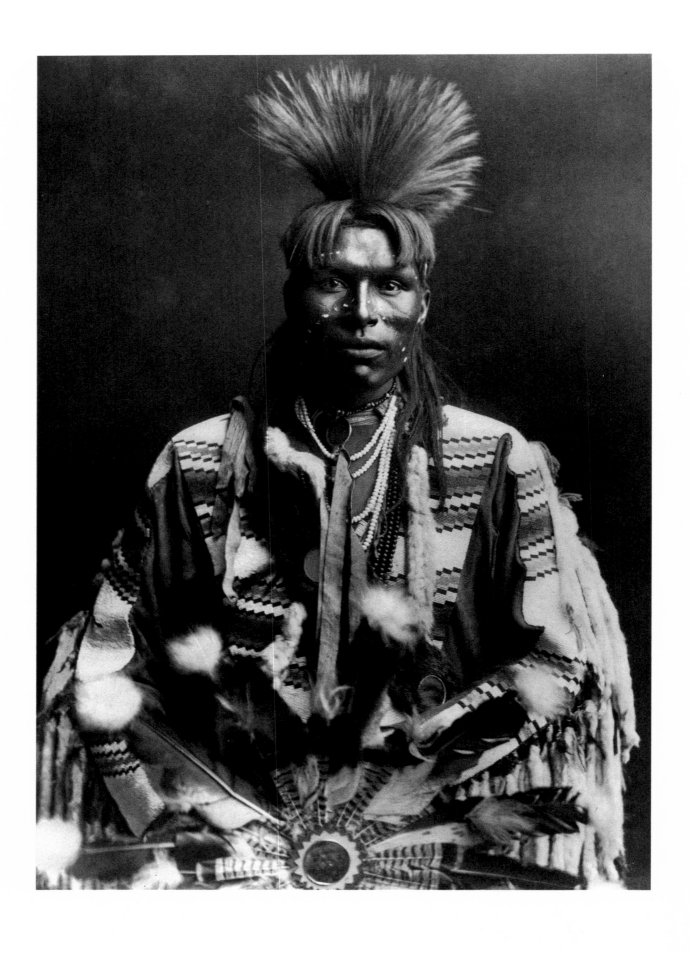

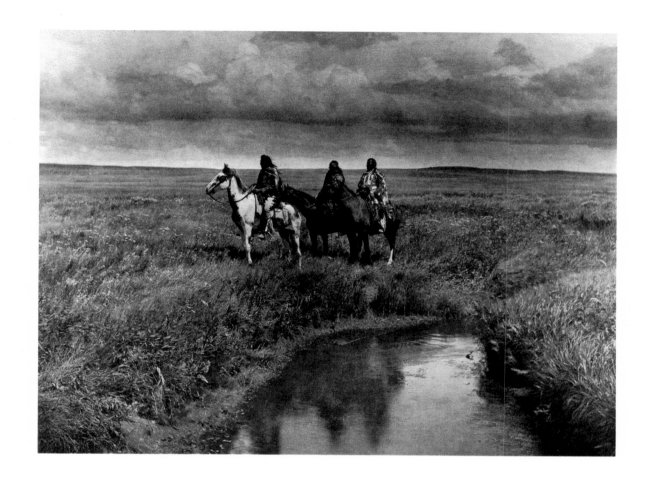

THE THREE CHIEFS - PIEGAN, 1900

A portrait of the primal upland prairies with their waving grass and limpid streams. A glimpse of the life and conditions on the verge of extinction. Their territory, yielding great quantities of furs and hides for barter, was an important one to traders. Those great rival corporations, the Hudson's Bay Company and the North West Company, established posts in their midst.

A PIEGAN DANDY, 1900

The Piegan, with the kindred Blackfeet and Bloods, were a vigorous people, noted hunters roaming over a vast territory, half in the western prairies of the United States and half in British America.

STORYTELLING - APACHE, 1903

A storytelling group, particularly typical of this tribe. The Apache often sit for hours exchanging stories. Linguistically the Apache belong to the great Athapascan family, which, according to the consensus of opinion, had its origin in the far north, where many tribes of the family still live. Based on the creation legends of the Navaho and on historical events, the advent of the southern branch of this linguistic group – the Navaho and the Apache tribes – has been fixed in the general region in which they now have their home, at about the time of the discovery of America.

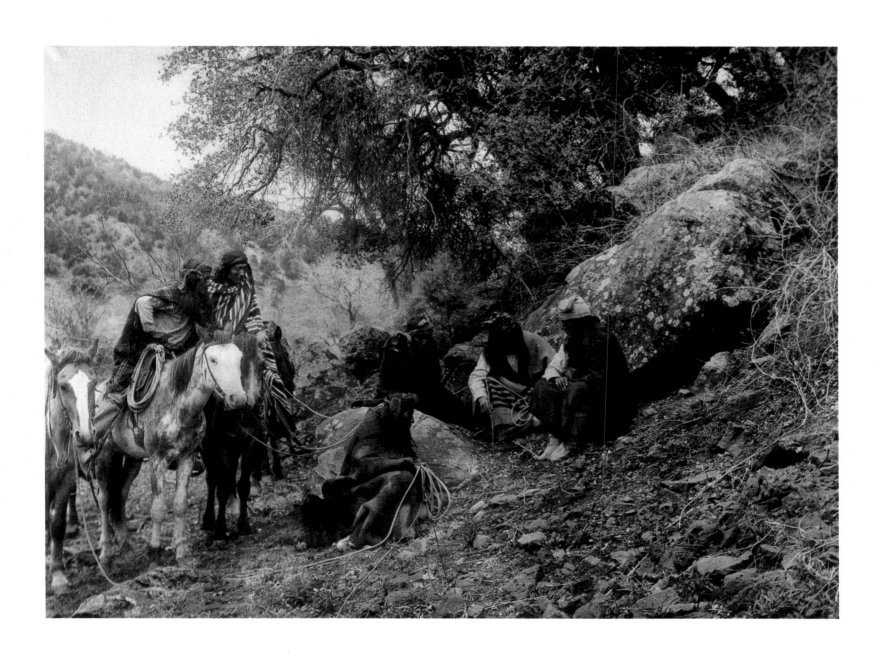

In the thick forests along the banks of mountain streams, the Apsaroke, or Crows, made their winter camps. Although not exclusively mountain dwellers, they were ever fond of hills, preferring the forest shade and the clear mountain streams to the hot, ill-watered, monotonous prairies. In stature and vigor the Apsaroke excelled all other tribes of the Rocky Mountain region, and were surpassed by none in bravery and in devotion to the supernatural forces that gave them strength against their enemies. Social laws, rigidly adhered to, prevented marriage of those even distantly related, and the hardships of their life as hunters eliminated infant weaklings. The rigors of this life made the women as strong as the men; and women, who could carry a quarter of a buffalo apparently without great exertion, ride all day and all night with a raiding war party, or travel afoot two hundred and fifty miles across an unmarked wilderness of mountains, plains and swollen streams in four days and nights, were not the women to bring forth puny offspring.

The Apsaroke were and are the proudest of Indians, and although comparatively few, they rarely allied themselves with other tribes for purposes of defense. For probably two and a half centuries they were the enemy of every tribe that came within striking distance, and for a goodly part of this time they were virtually surrounded by hostile bands with a common hatred against this mountain tribe that likened itself to a pack of wolves. The swarming thousands of the western Sioux, aided by the Cheyenne and Arapaho, tried to force them westward. The powerful Blackfeet invaded their territory from the north and northwest, Flatheads and Nez Percés were worthy foes from the west, and the wily Shoshoni pressed in from the south; yet the Apsaroke were ever ready to repel invasion from whatever direction it might come. In the Apsaroke is seen the highest development of the primitive American hunter and warrior. Physically these people are among the finest specimens. They clothed themselves better and dwelt in larger and finer lodges than did their neighbors, and decked their horses in trappings so gorgeous as to arouse the wonder of all early explorers.

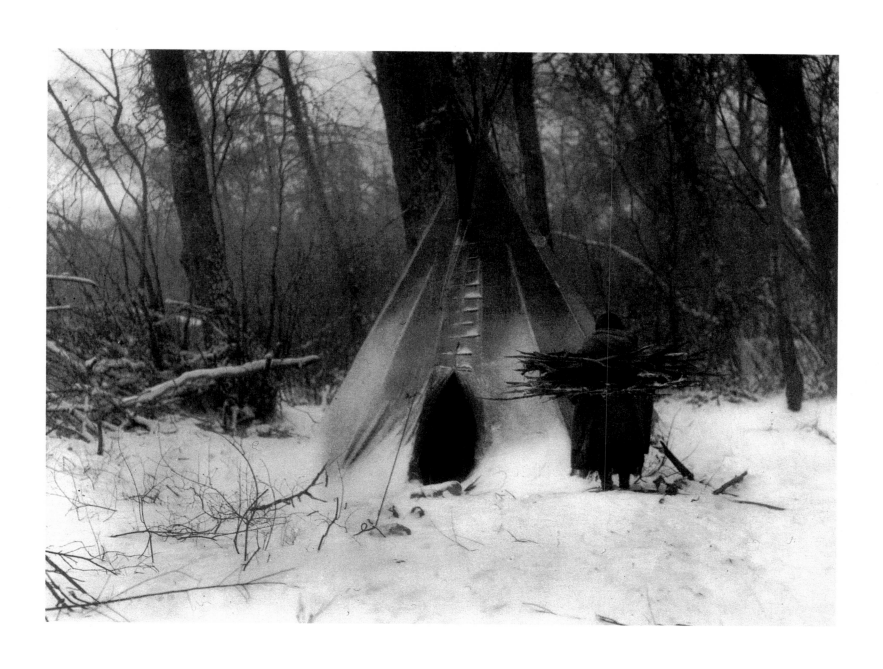

SHOT IN THE HAND - APSAROKE, 1908

Born about 1841. Counted three dakshe, captured three guns and one tethered horse, but lacked the medicine to become a war-leader. Seven times he struck an enemy who was firing at him. Four times in as many different fights he seized an unharmed enemy by the hair and hurled him from his horse. He "threw away" seven of his eight wives.

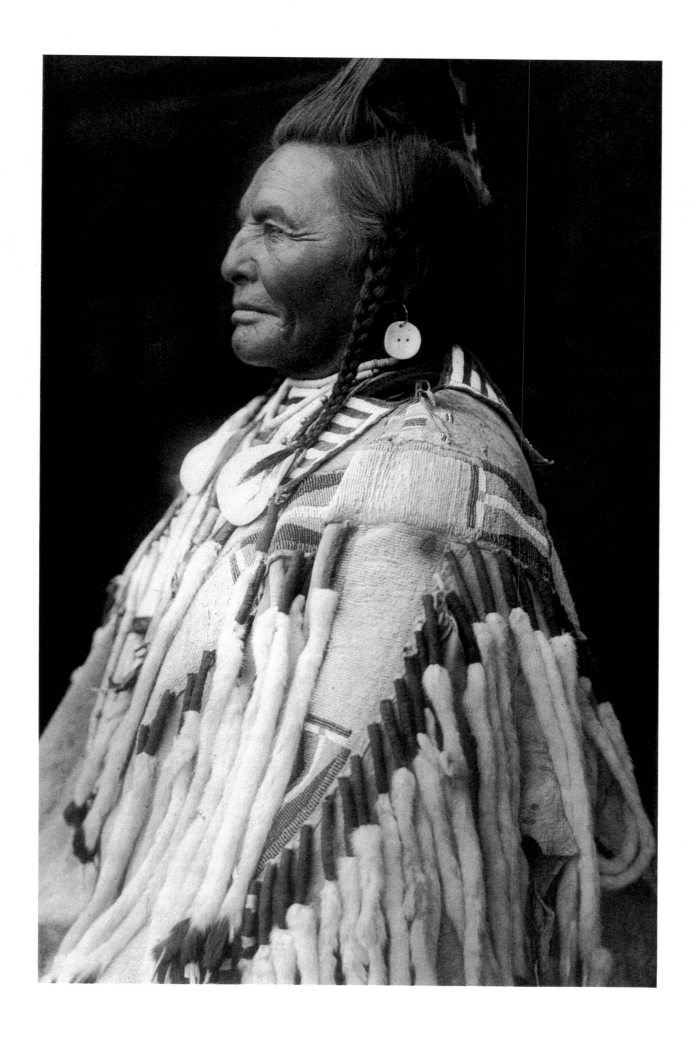

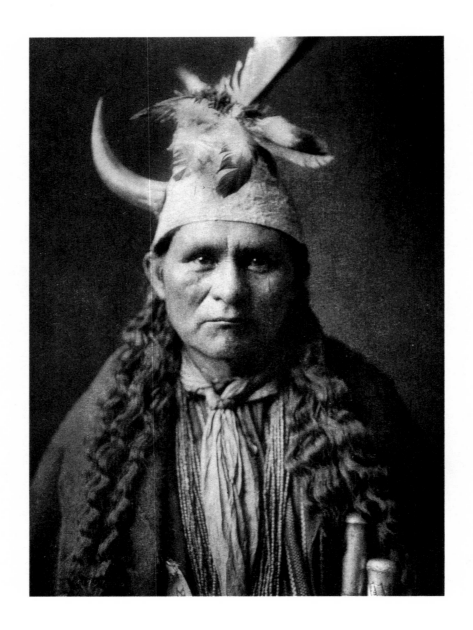

OYEGI-A-YE "FROST MORNING" - SANTA CLARA, 1905

A Governor of Santa Clara, which with San Juan, San Ildefonso, Nambe and Tesuque comprised the Tewa pueblos of New Mexico. The farther north one goes among the Tewa the more evident it becomes that there is a strong infusion of Plains Indian blood.

IRON BREAST - PIEGAN, 1900

This picture illustrates the costume of a member of the society of Bulls, an independent company of old men formed, probably about 1820, by a man who, in a dream in the mountains, saw a certain kind of dance, and on his return made the necessary insignia, sold it to a number of old men, and instructed them in song and dance.

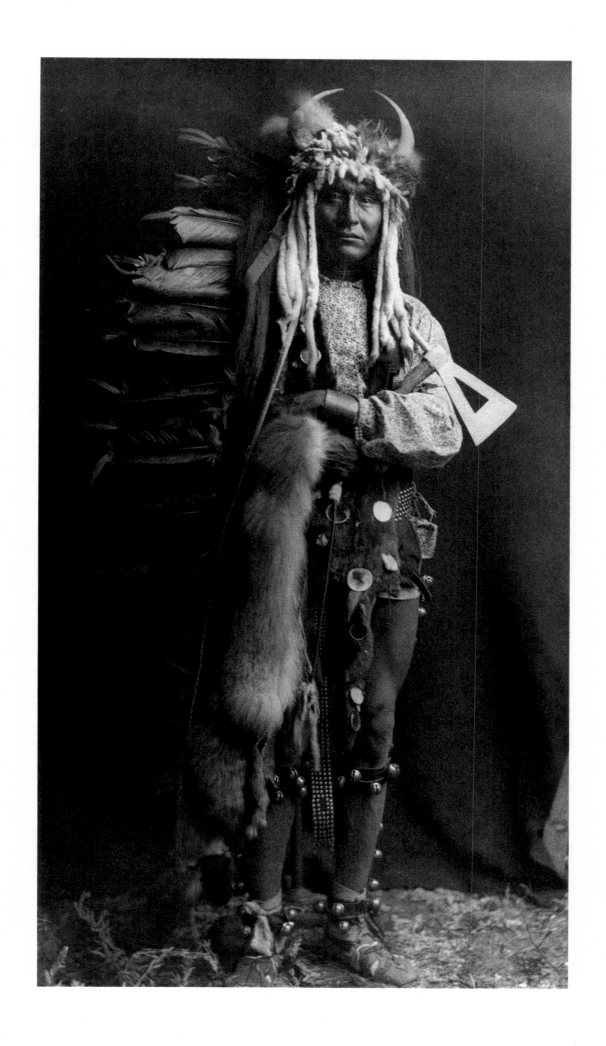

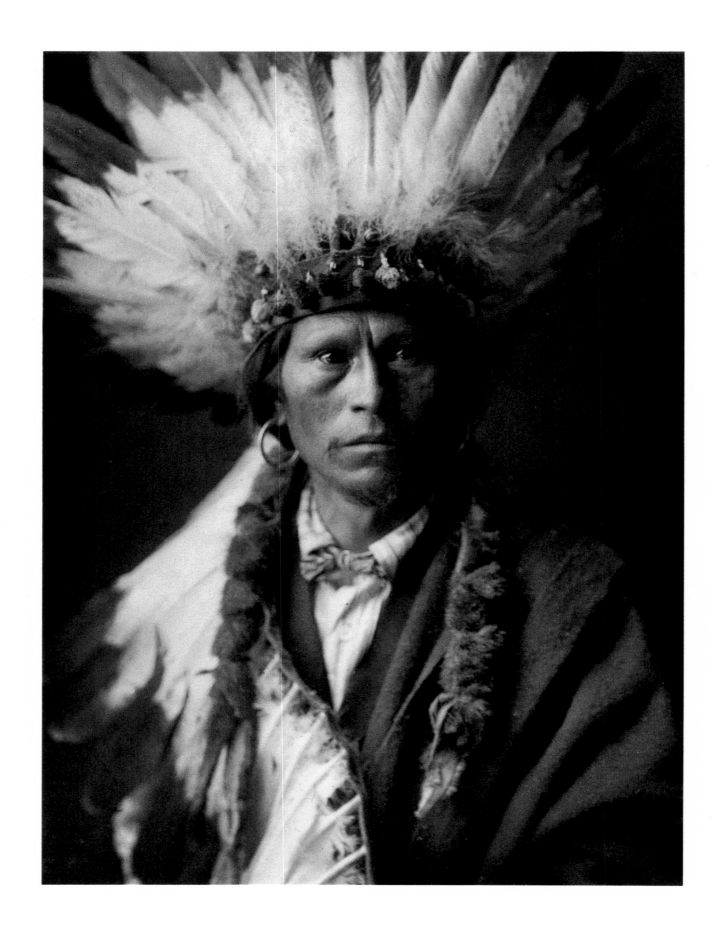

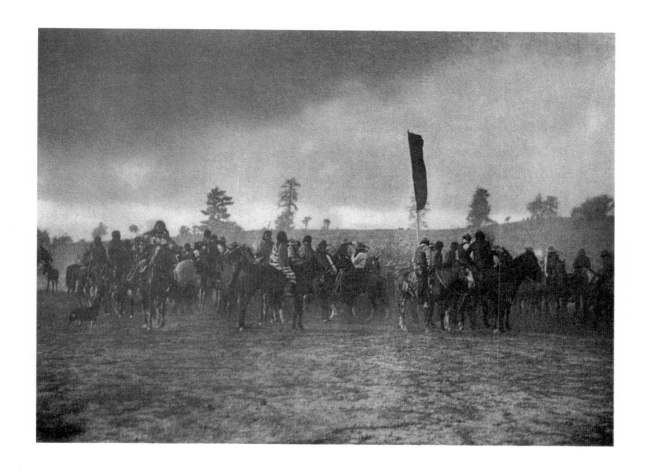

JICARILLA FEAST MARCH, 1904

Features of the fiesta have been borrowed directly from the Pueblos of northern New Mexico. Too small in numbers to resist the cultural influence of other tribes, and having been too long in contact with the buffalo hunters of the Great Plains as well as in close touch with the pueblo of Taos with its great wealth of ceremony and ritual, it is not surprising that the Jicarillas, in life and ceremony, have been deeply influenced by adjacent tribes.

CHIEF GARFIELD - JICARILLA, 1904

The Jicarillas, or as they are commonly called, "Jicarilla Apaches," occupy a reservation of nearly four hundred and fifty square miles of mountainous country in northern New Mexico. Linguistically the Jicarillas are of the same stock as the Apache of Arizona; but here the relationship ceases, for the two peoples have virtually no knowledge one of the other, and the dialect, mythology, legends, and medicine rites of the Jicarillas more closely resemble those of the Navaho than of the Apache groups In dress the Jicarillas resemble the Indians of the plains, even to the feather headdress, which is never worn by the tribes to their south and west All Jicarillas were officially given Spanish or English names. Many of them expressed a preference. This old man, who was head chief, selected the designation Garfield.

WISHHAM GIRL - WISHHAM, 1910

The girl is clothed in a heavily beaded deerskin dress of the Plains type. The throat is encircled by strands of shell beads of native manufacture, heirlooms which were obtained by the original Wishham possessor from the Pacific slope. Hanging on the breast are strands of larger beads of the same kind, as well as of various shell beads brought into the country by traders of the Hudson's Bay Company. An indispensable ornament of the well-born person was the dentalium shell thrust through a perforation in the nasal septum; occasionally, as in this case, two such shells were connected by means of a bit of wood pushed into the hollow bases. Tied to the hair at each side of the face is another dentalium shell ornament, which is in reality an ear pendant transferred from the lobe of the ear (where its weight would be inconvenient) to the hair. The headdress consists of shells, shell beads, commercial beads, and Chinese coins. The coins made their appearance in the Columbia River region at a comparatively early date. This form of headdress was worn on special occasions by girls between the age of puberty and their marriage.

The Wishham are an inland extension of the Chinookan stock of the Pacific Coast and the lower Columbia River; they are sedentary dwellers by the swift waters of the Columbia. In place of the horse, their means of travel was the picturesque high-prowed canoe common to the Pacific waters from the Columbia River to Yakutat Bay in Alaska. Their homes were not tents of skin, nor wickiups of reeds, but rather substantial structures of split timbers and planks. They were a slave-holding community, possessing much pride of caste, and imbued with beliefs of magic to an unusual degree. Their myths possess a delightful wealth of imagination, and are all-embracing in their personification of the animal and inanimate.

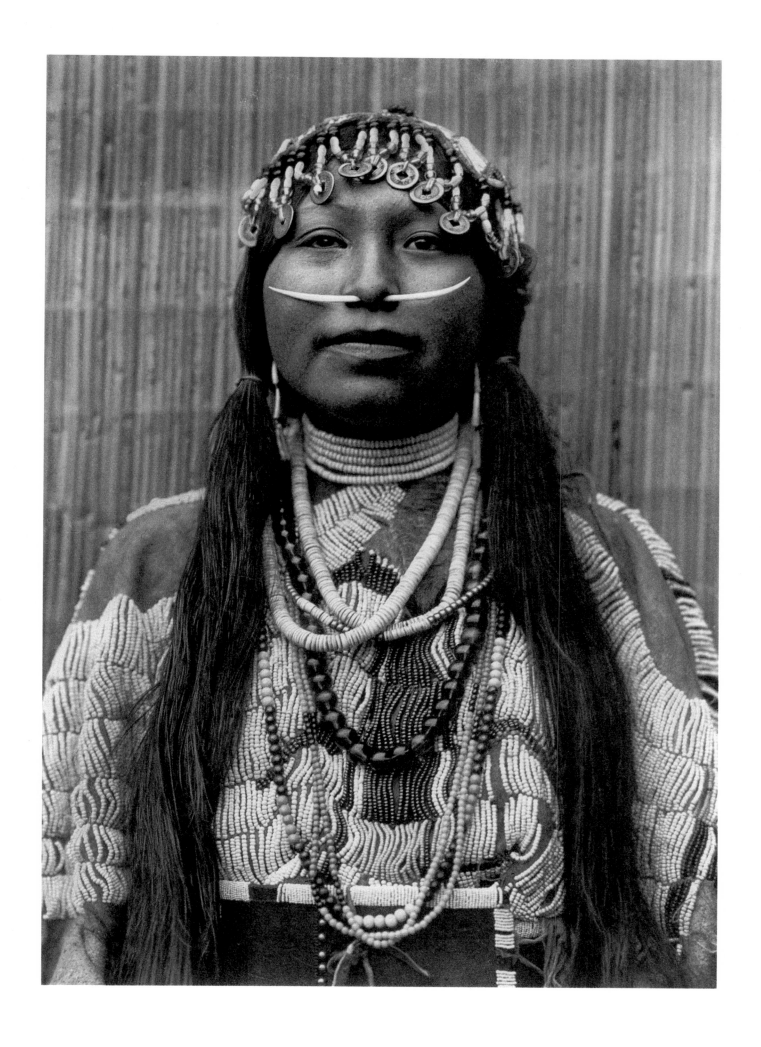

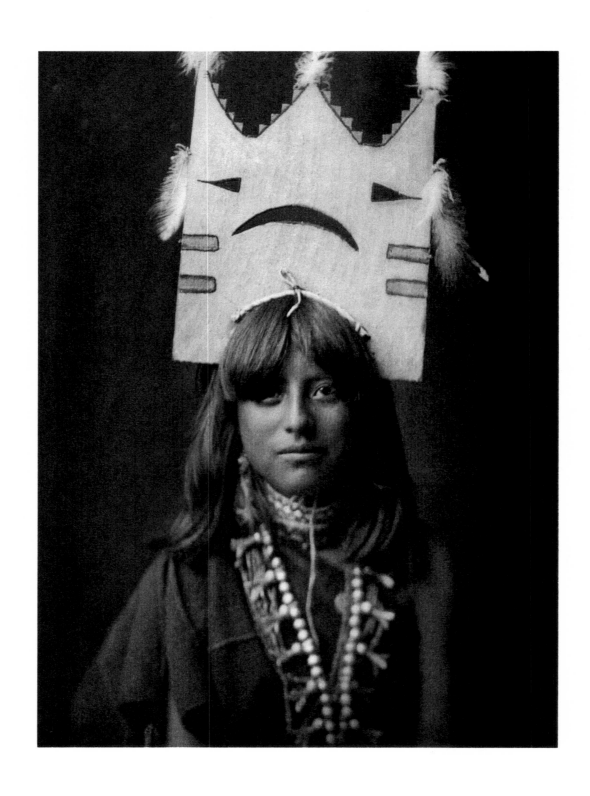

TABLITA WOMAN DANCER - SAN ILDEFONSO, 1905

The ceremony called Kohéye-liyárě, "tablita dance," popularly called the Corn dance, occur-
ing in June and again in September, is characterized by public dancing and singing for the pur-
pose of bringing rain clouds. The name refers to wooden "tablets" worn by female dancers.

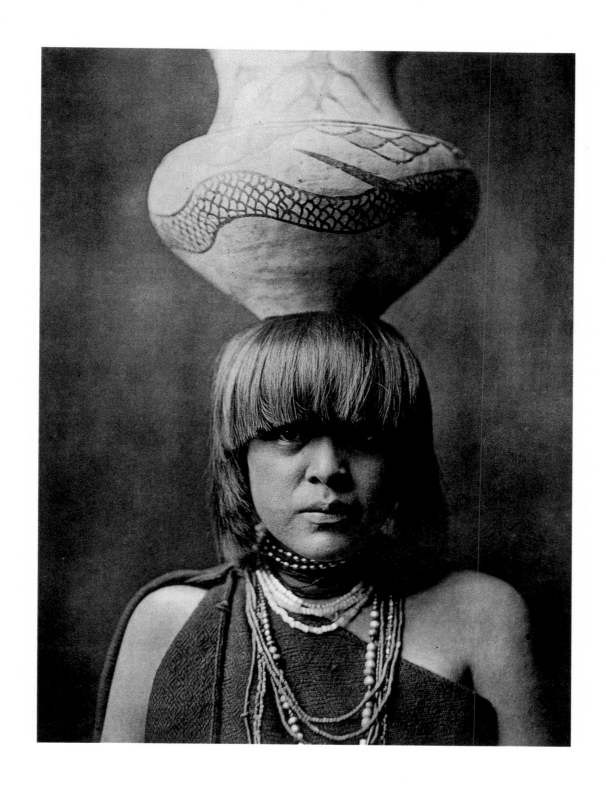

GIRL AND JAR - SAN ILDEFONSO, 1905

Pueblo women are adept at balancing burdens on their heads. Usually a vessel rests on a fiber ring, which serves to steady it and to protect the scalp. The design on the jar recalls the importance of the serpent cult in Tewa life.

AT THE OLD WELL AT ACOMA, 1904

The Keres village of Acoma is the oldest continuously occupied settlement in the United States. Perched on the top of the mesa some three hundred and fifty feet above the surrounding valley, it is accessible only by difficult trails partly cut in the solid rock of its precipices. Members of Coronado's army of explorers in 1540 and Espejo in 1583 noted the "cisterns to collect snow and water" on the rock of Acoma.

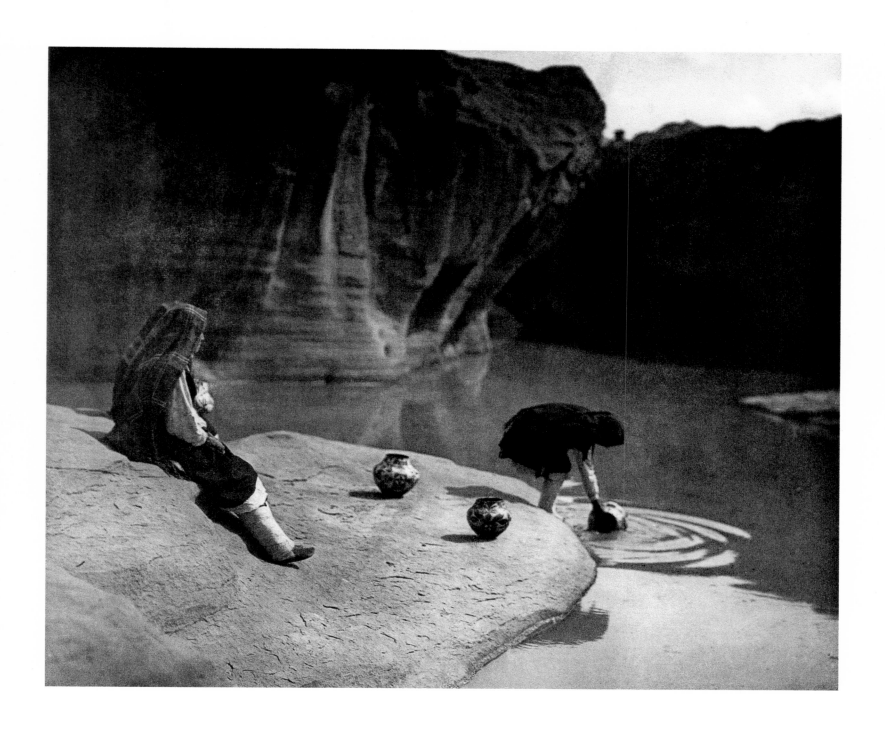

KUTENAI DUCK HUNTER - KUTENAI, 1910

In the gray dawn of a foggy morning the hunter crouches in his canoe among the rushes, waiting for the waterfowl to come within range. The Kutenai, not known to be linguistically related to any other tribe, occupy portions of southeastern British Columbia, northern Idaho, and northwestern Montana. In this region of blue, mountain-girded lakes and majestic rivers, they very naturally made use of canoes. The commoner form was the pine-bark craft, but occasionally they made canoes by stretching fresh elk hides over a framework of fir strips or tough saplings.

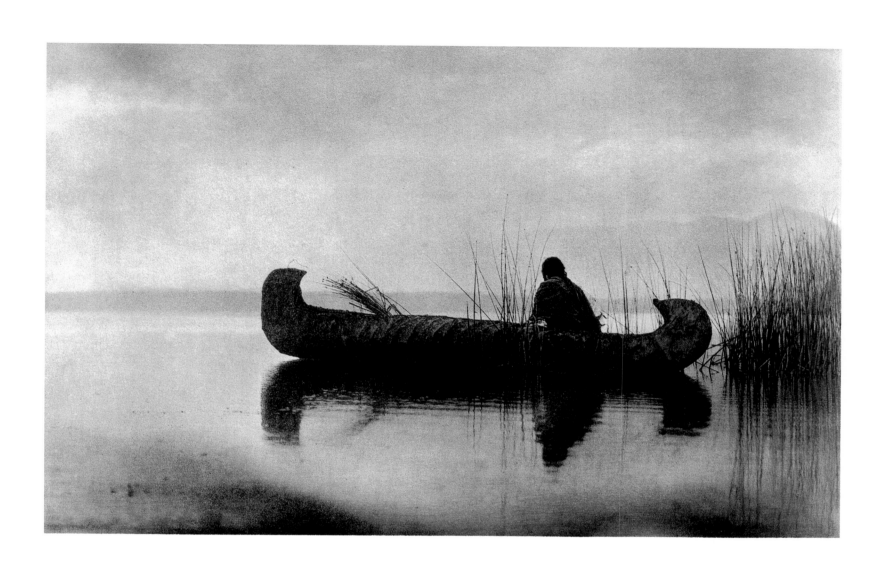

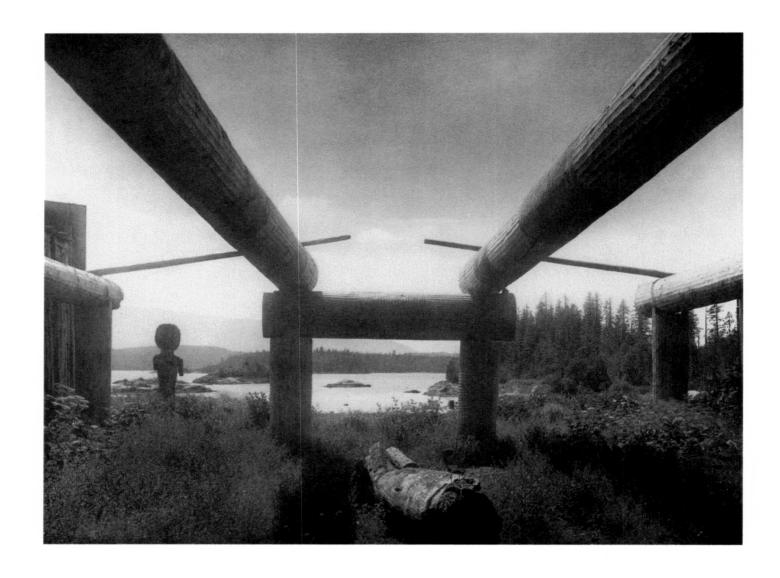

KWAKIUTL HOUSE FRAME - KWAKIUTL, 1914

The two long beams in the middle are twin ridge timbers, which are supported in the rear, as in the front, by a transverse beam resting on two uprights. At the extreme right and left are the eaves-timbers. The longitudinal and circular flutes of the columns are laboriously produced by means of a small hand-adze of primitive form. This frame is at the village Memkumlis, home to one of the large number of cognate tribes – including the Quatsino, the Koskimo, the Nakoaktok, the Tsawatenok, the Koeksotenok – on the coast of British Columbia comprising the Kwakiutl, or Qágyuħl.

KÓTSUIS AND HÓHHUQ - NAKOAKTOK, 1914

These two masked performers in the winter ceremony represent huge, mythical birds. Kótsuis and Hóhhuq are servants in the house of the mythical man-eating monster Páhpaqalanóhsiwi, the personification of the ravaging wind, who carries away the body of a man as the tornado snatches up the bodies of his victims. The winter ceremony is called tséfŝehka ("secrets," or "tricks of the legerdemain"). During a period of about four months, beginning usually in the middle of November, the members of the secret society devote themselves exclusively to the winter dances and accompanying feasts, potlatches, payment of marriage debts, and other festivities. No work not absolutely essential to existence or to the progress of the ceremony is performed. The Kwakiutl ceremonies are rich in mythology and tradition. In their development of ceremonial masks and costumes they are far in advance of any other group of North American Indians.

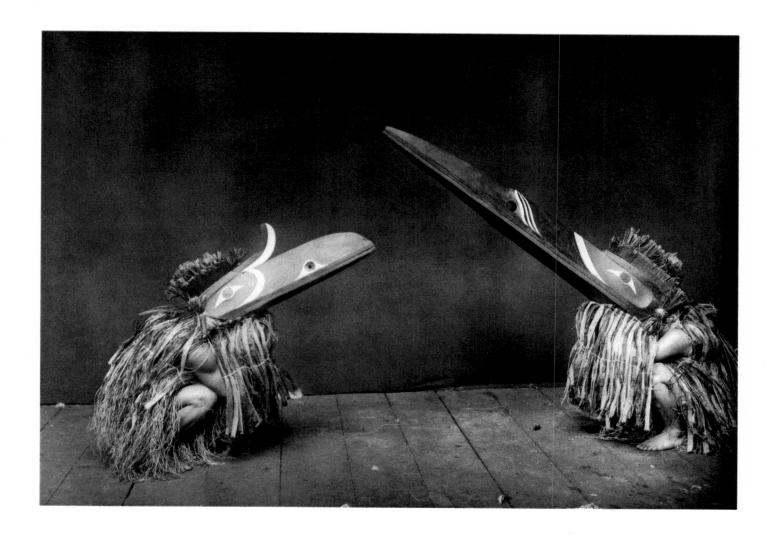

MASKED PERFORMERS REPRESENTING OTHER SERVANTS OF PÁHPAQALANÓHSIWI IN THE WINTER DANCES - QÁGYUHL, 1914

I Táwihyilaħl "mountain-climber (mountain-goat) embodiment"; II Grizzly Bear dancer; III Kalóqǔŝuis ("curved beak of the upper world"), a huge bird; IV Hamasīlaħl ("wasp-embodiment")

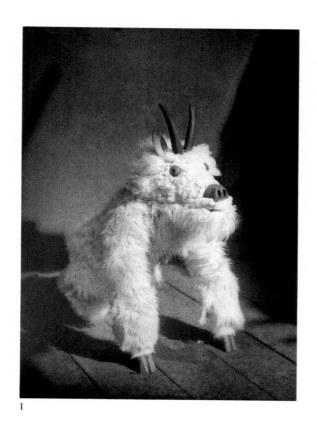

II

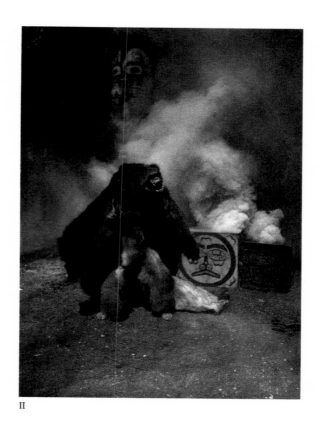

IV

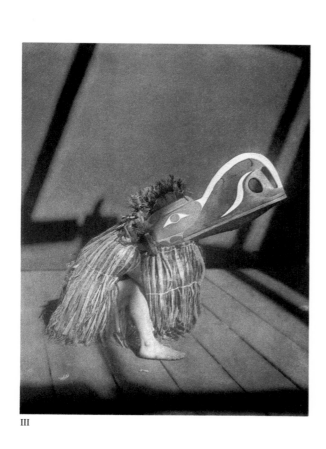

I

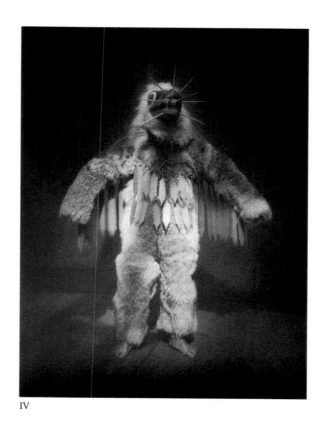

III

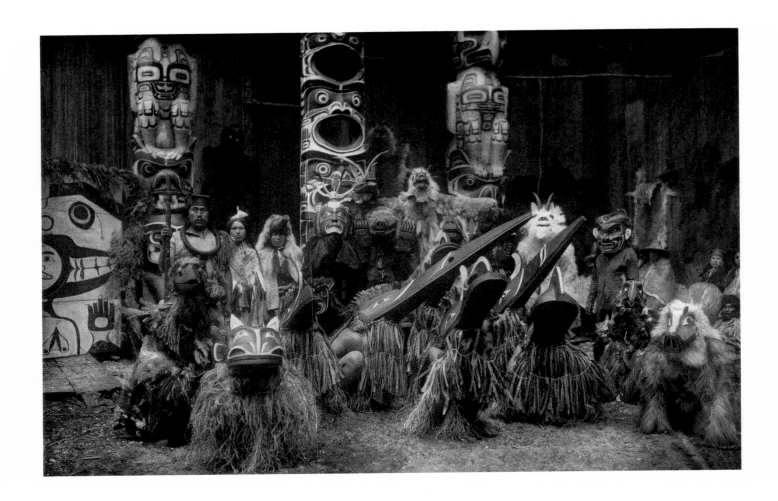

GROUP OF MASKED DANCERS - QÁGYUHL, 1914

More masked and costumed performers in the winter ceremony. The chief who is holding the dance stands at the left, grasping a speaker's staff and wearing a cedar bark neck-ring and headband, and a few of the spectators are visible at the right. At the extreme left is seen a part of the painted máwiħl through which the dancers emerge from the secret room; and in the center, between the carved house-posts, is the Awaitlala háms'pĕk, showing three of the five mouths through which the hamatsa wriggles from the top to the bottom of the column.

A TLŬ-WŬLÁĦŬ MASK - TSAWATENOK, 1914

Tlŭ-wŭláħŭ is a four-day dance occurring just before the winter ceremony. It is not limited to the secret society that controls the winter dance, but it is open to all. Summer names and summer songs are employed. The Tsawatenok are an inland and river tribe, depending on the sea for their sustenance much less than do most Kwakiutl tribes, and to an equal degree devoting more time to hunting and trapping in the mountains. Their territory lies along Kingcome River, at the head of the long, mainland indentation known as Kingcome Inlet.

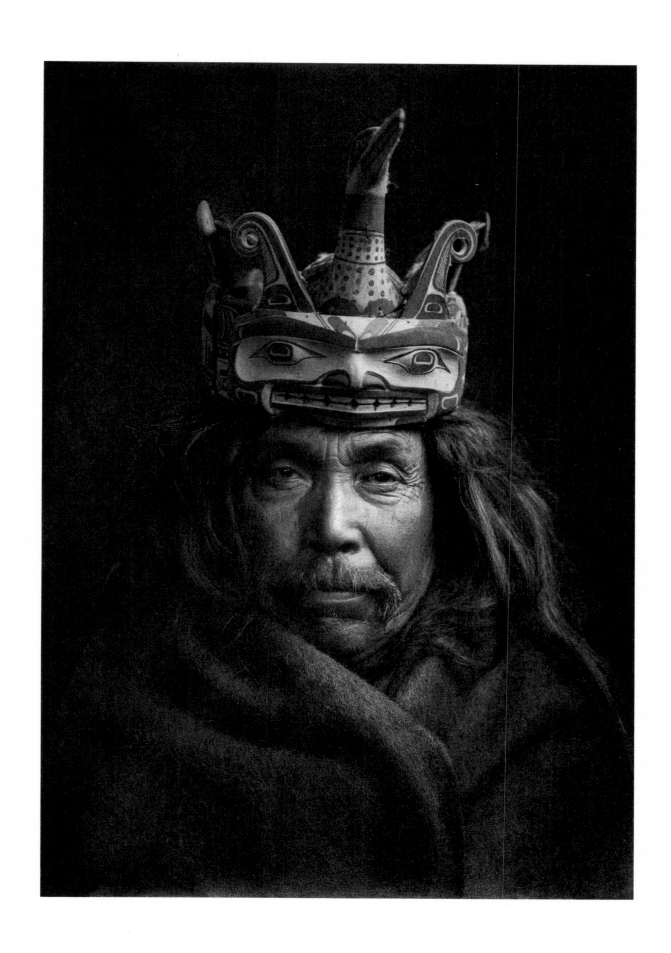

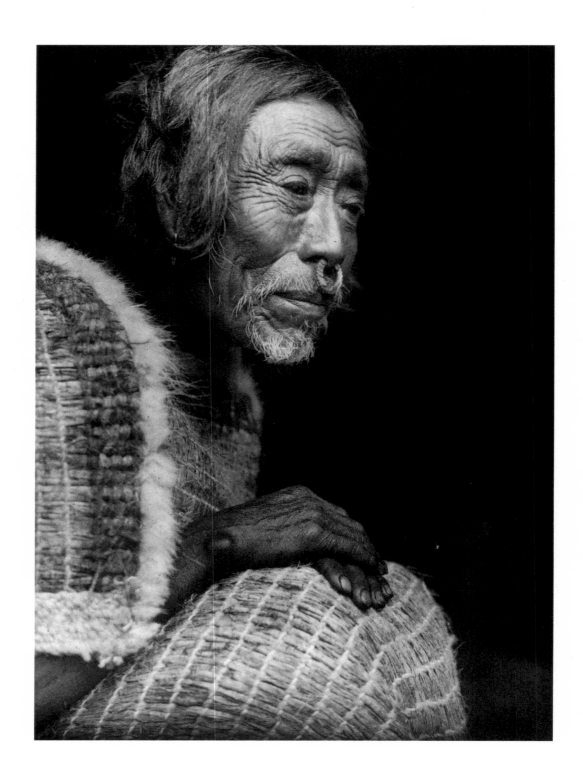

YÁKOTLŬS - QUATSINO, 1914

This plate illustrates the artificial deformation of the head, which formerly was quite general on the North Pacific coast. On the fourth day after a child's birth, its forehead was wrapped tightly with a two-inch strip of deerskin or of thin, dry kelp and a pad of floss for four months, the purpose being to produce a straight line from the tip of the nose to the crown of the head. It was regarded as little less than disgraceful for any one, especially a woman, to have a depression where nose meets forehead. While no diminution of intellect is observable in those whose heads are deformed, it is said that infants just released from the bandage and pad were as helpless as month-old babies.

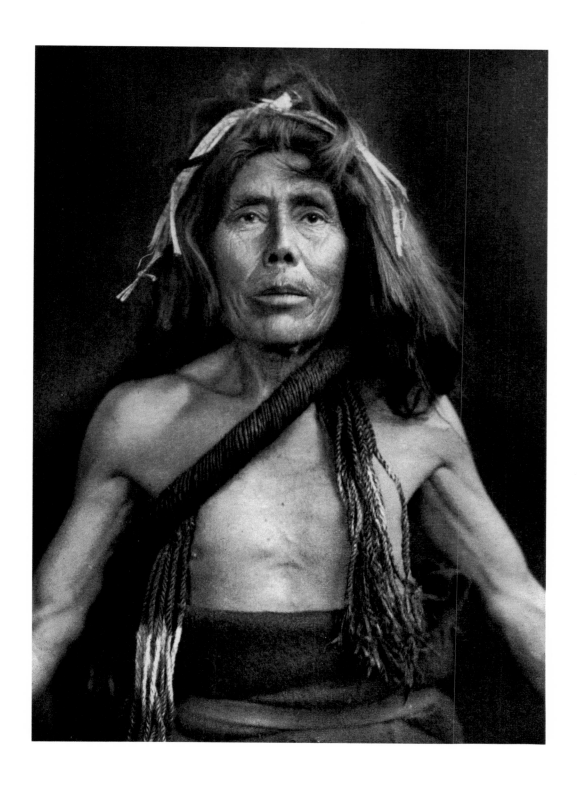

KÉK̇ŬḢTLALA - KOEKSOTENOK, 1914

The Koeksotenok ("opposite shore people") lived on Gilford Island, some at their ancient seat Kwaustums in company with the predominating Tsawatenok, others with the Mamlelekala on Village Island. Their summer homes are on Háta, a small stream on the neck of land between Bond Sound and Kingcome Inlet.

PIEGAN ENCAMPMENT, 1900

The picture not only presents a characteristic view of an Indian camp on an uneventful day, but also emphasizes the grand picturesqueness of the environment of the Piegan, living as they do almost under the shadow of the towering Rocky Mountains.

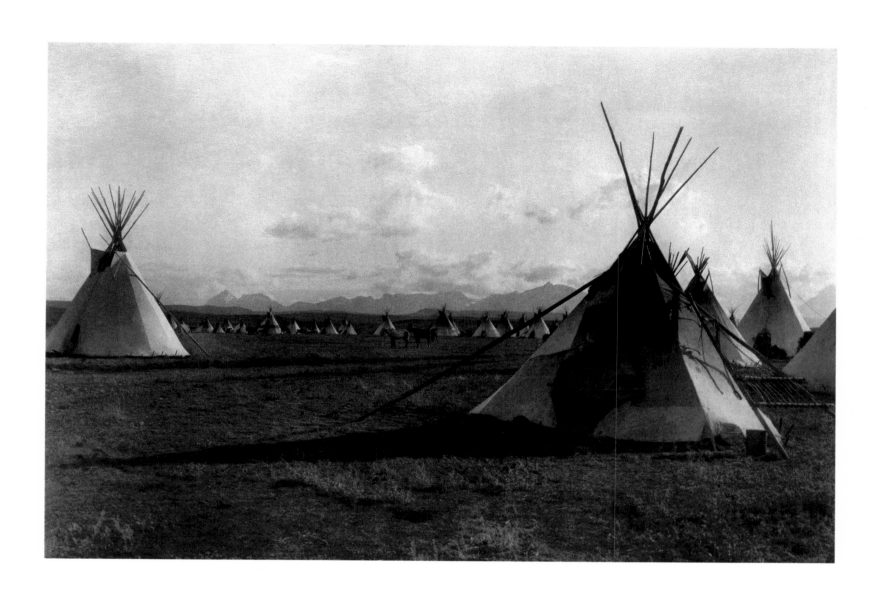

A BURIAL PLATFORM - APSAROKE, 1908

The early method of disposing of the dead was to place the body in a niche or cave among the rocks. But scaffold burial began to be the ordinary form during the chieftainship of Red Feather At The Temple. It was said the dead were going away on a visit; consequently before or immediately after death, the body was prepared and dressed in the best clothing of the deceased, that of a warrior being arrayed and painted as for war. Thus wrapped securely in skins and lashed with rawhide ropes, the knees being bent and drawn up toward the body, the deceased was laid partially on its side in a rude coffin made by hollowing out a dry cottonwood log.

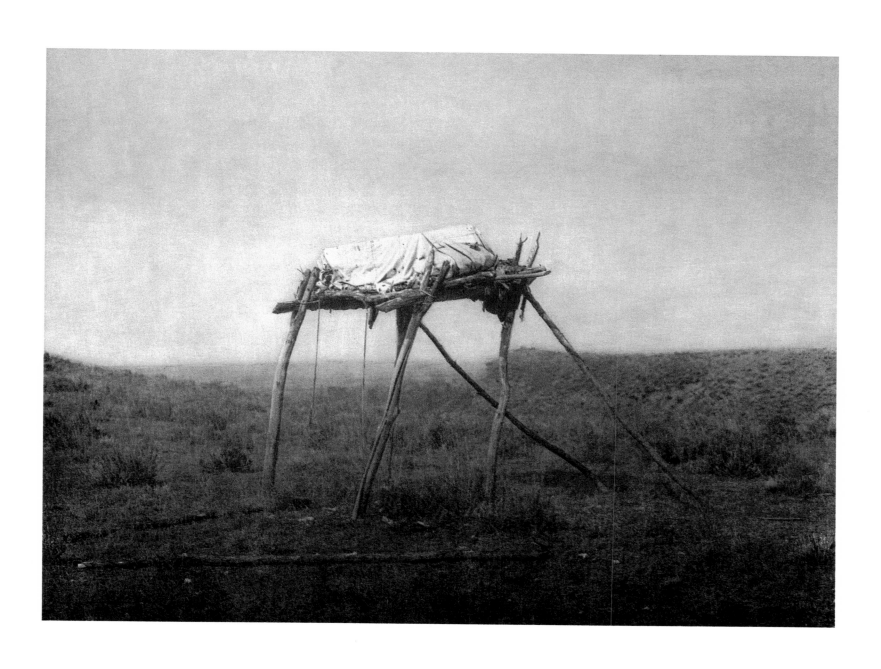

TAOS WATER GIRLS, 1905

Taos - the most northern of the Pueblo tribes populated this mountain village – consists of two house-masses separated by Pueblo Creek. The entire site was formerly surrounded by a protective wall, remains of which are still in place.

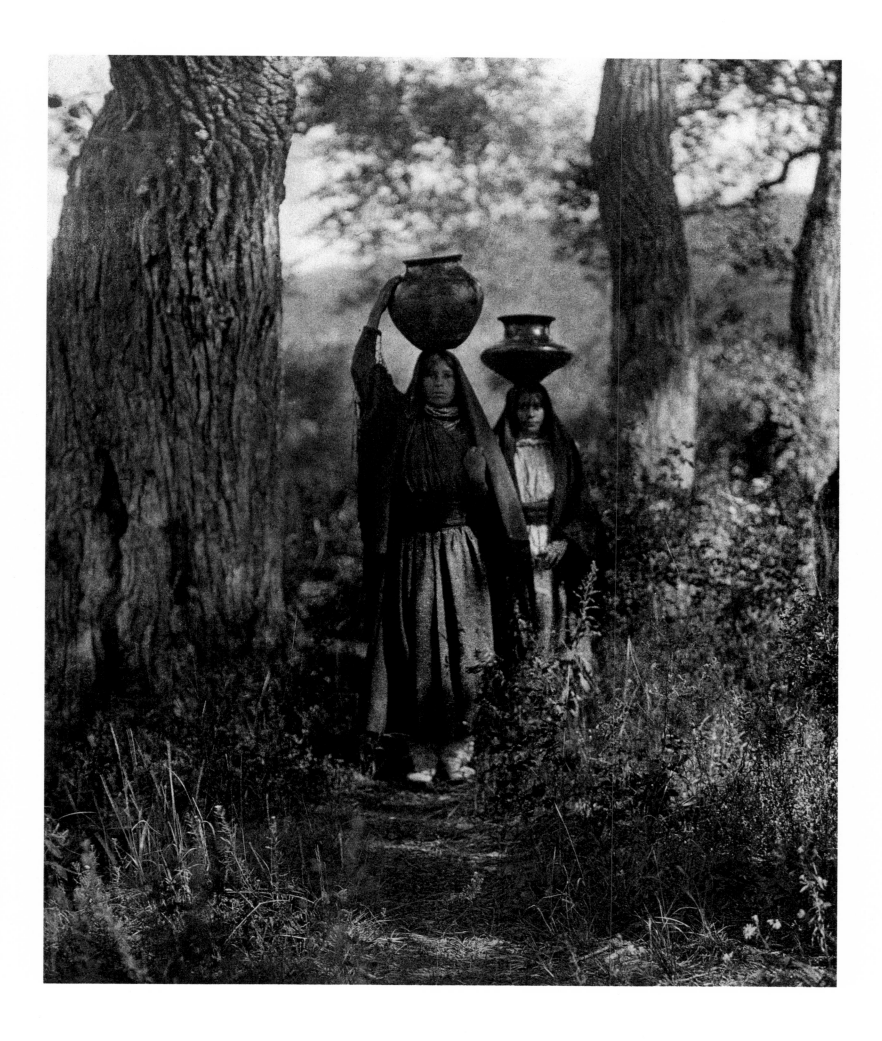

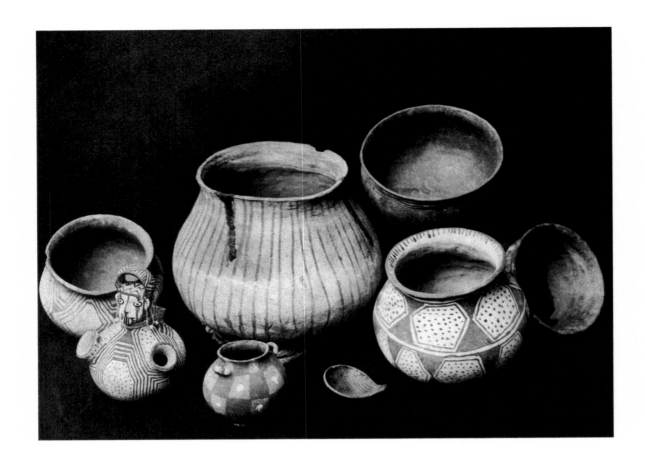

MOHAVE POTTER AND STILL LIFE, 1907

A barren earth and a sunless sky came together, begetting gods and people. Such, according to the myth, is the genesis of the Mohave, one of the principal branches of the Yuman family, possibly the parent people of the stock.

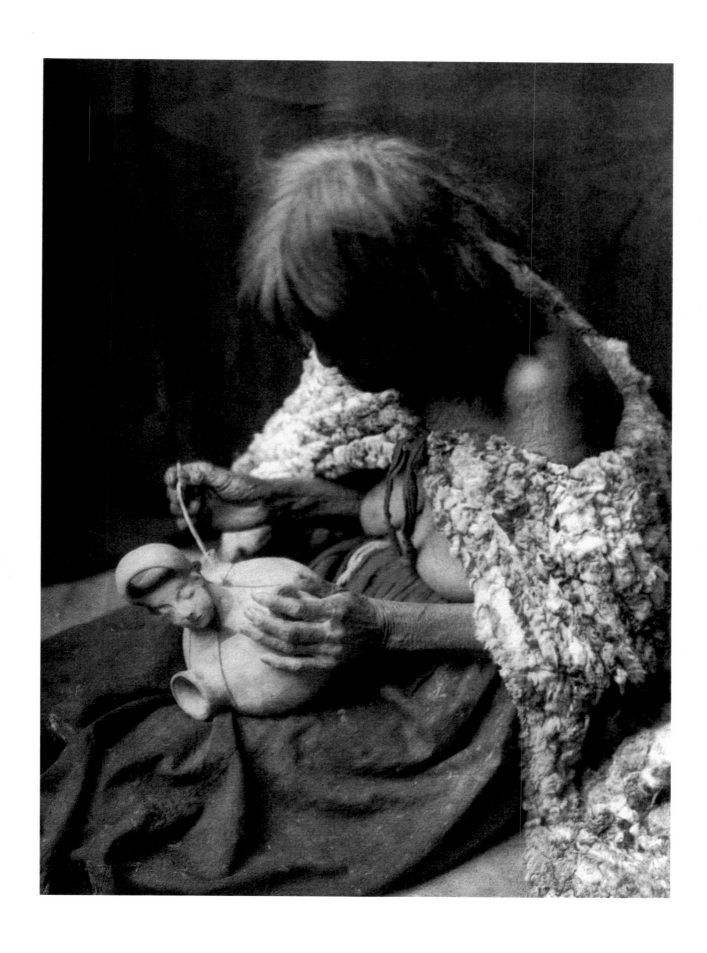

^I DANCING MASK - NOOTKA, 1915

The Nootka tribes, composing one branch of the great Wakashan linguistic stock, of which the Kwakiutl are the other, inhabit the west coast of Vancouver island from Cape Cook to Port San Juan, and, in the United States, the territory about Cape Flattery from Hoko Creek to Flattery rocks. This mask is called Ha'wá'nahat ("always ready to feed"). The original Ha'wá'nahat, according to mythology, was one of four slaves who were transformed into speaking house-posts in the first winter-dance house.

^{II} MATERNITY BELT - APACHE, 1907

When childbirth approaches, the medicine men are always summoned. Nothing can give a better idea of the medicine rites on such an occasion, and of the use of sacred pollen, than a description of a maternity belt procured by the writer and here illustrated. So far as can be learned, this belt is very old, so old that its painted symbolic figures have been three times renewed. Belts of this kind are very rare, and are hired whenever their use is required. The owner of this particular belt, a widow, did not care to dispose of it; as she expressed it, "it is like a husband:" the remuneration from granting its use was sufficient to support her.

The belt is made from the skin of the mountain lion, the black-tail deer, the white-tail deer, and the antelope – animals which give birth to their young without trouble. Medicine men are called in to pray to the spirits of these animals when a woman approaching confinement puts on the belt. It is worn for a day or so only, but constantly through the critical period, not being removed until after the child is born. Prayers are made, first by a mother or father for their daughter, then by a medicine man, and lastly by the patient to the gods and elements depicted on the belt.

^{III} STICKS USED IN HUPA GUESSING GAME, 1923

The Hupa have only a few games. The guessing contest played by men is called kin ("stick"). Each of two players has about one hundred very thin, round sticks, one of which is distinguished by a black band. These are obtained in the mountains, in order that they may be lucky. A player puts his hands behind his back and separates the sticks into two lots, brings them forward, and holds them beside his thighs, while his backers beside and behind him, who have wagered their valuables on his success, beat a drum, clap and sing. The other studies his opponent's face, then suddenly claps his hands and makes a gesture indicating which hand, in his opinion, contains the black-banded stick. If the guess is successful, the inning passes to him; but if unsuccessful, the player takes from the space between them one of twelve tally-sticks. The entire number of sticks must be in possession of one player or the other, in order to decide the wager. When a player has ten of them, the "dealer" announces "two left!" Then a successful play on his part concludes the game.

^{IV} MEDICINE CAP AND FETISH - APACHE, 1907

This plate shows a medicine cap made by Yotluni, a medicine man, to cure a boy of lightening stroke which had impaired his reason, and a small wooden image of the God of Health, Pollen Boy, recently made to be carried by a girl troubled with nervousness. On both these objects the gods and elements which cause these afflictions and which alone can give relief are symbolically represented. As the boy soon recovered, the virtue of the cap was attested, and subsequently its owner often hired it to others.

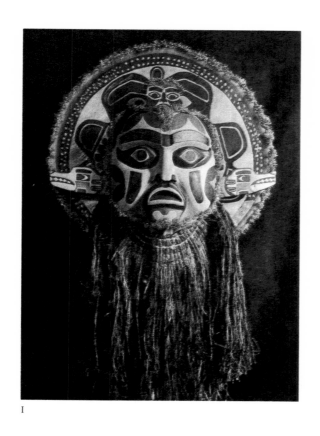

I

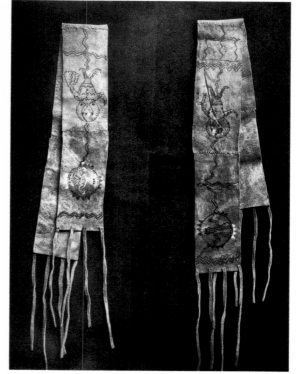

II

III

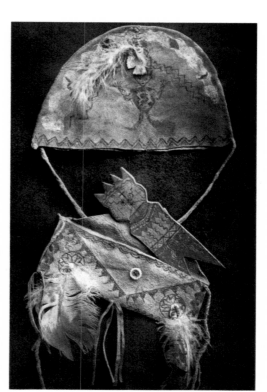

IV

THE BLANKET WEAVER - NAVAHO, 1904

In Navaho-land blanket looms are in evidence everywhere. The origin of the textile art among the Navaho is an open question. The mummies found in the prehistoric cliff-ruins of the Navaho country are wrapped in cloth finer than any ever produced with a Navaho loom, and no doubt now remains that Pueblo people were incorporated by the Navaho in ancient times. In the winter months, the looms are set up in the hogans, but during the summer they are erected outdoors under an improvised shelter, or, as in this case, beneath a tree. The simplicity of the loom and its product are here clearly shown, pictured in the early morning light under a large cottonwood The Navaho are a pastoral, semi-nomadic people whose activities center on their flocks and small farms. Their reservation of more than fourteen thousand square miles is the desert plateau region of northern Arizona and New Mexico. While the Navaho leads a wandering life, the zone of his movements is surprisingly limited; indeed the average Navaho's personal knowledge of his country is confined to a radius of not more than fifty miles. The family usually has three homes, the situation of which is determined by the necessities of life. Their dome-shaped, earth-covered hogans are usually grouped two or three in the same locality. The summer house is a rude brush shelter, usually made with four corner posts, a flat top of brush, and a windbreak of the same material, as a protection against the hot desert siroccos. The hogan proper, used for storage during the summer, offers a warm and comfortable shelter through the cold winters in high altitudes.

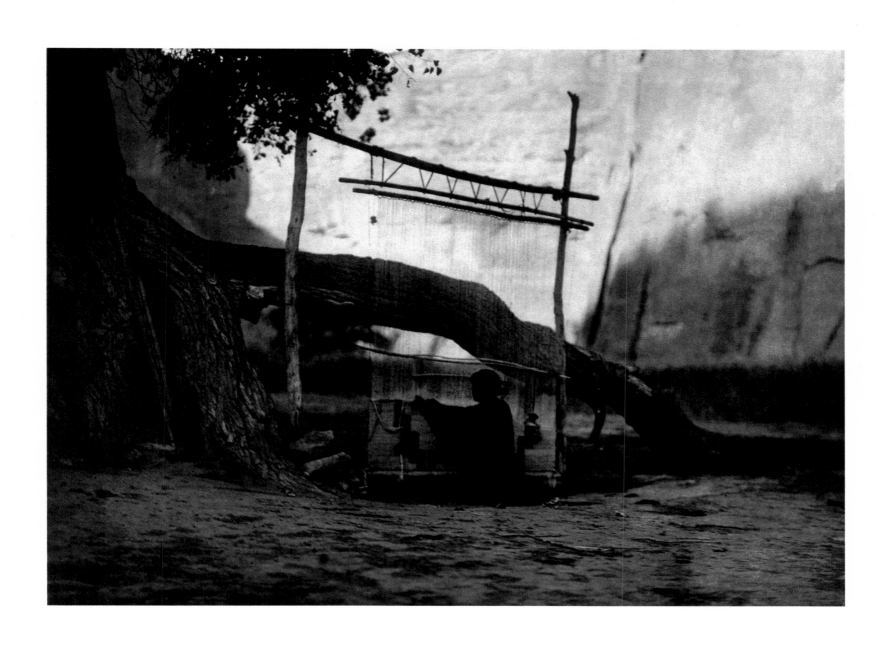

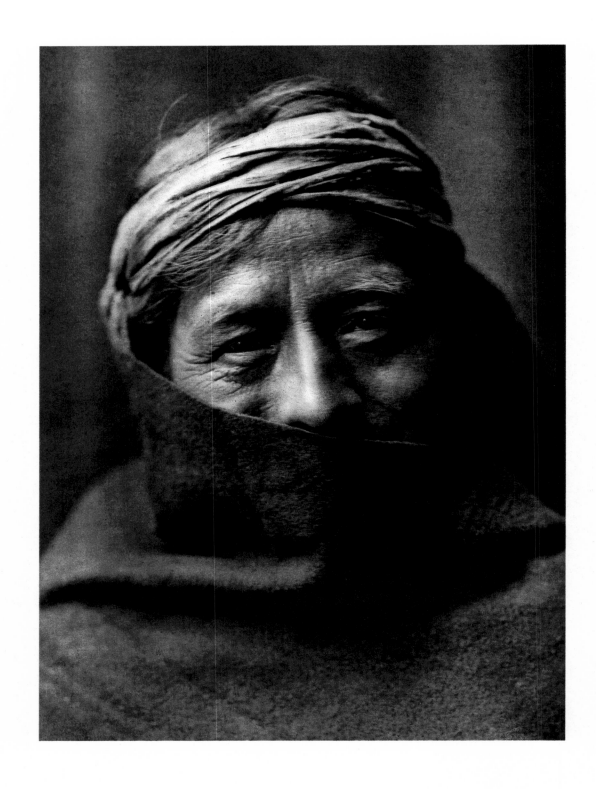

WAIHUSIWA, A ZUÑI KYÁQIMÂSSI - ZUÑI, 1903

Kyáqimâssi ("house chief") is the title of the Shiwánni of the north, the most important of all Zuni priests. Waihusiwa in his youth spent the summer and fall of 1886 in the East with Frank Hamilton Cushing, and was the narrator of much of the lore published in Cushing's *Zuñi Folk Tales*. A highly spiritual man, he is one of the most steadfast of the Zuñi's priests in upholding the tradition of the native religion. Zuñi, lineal descendant of the glamorous Seven Cities of Cibola so eagerly sought by the conquistadores, occupies a portion of the site of Halona, one of those all but prehistoric towns, on the north bank of Zuñi River in the extreme western part of New Mexico not far from the Arizona boundary. The tribe has been concentrated in this pueblo for nearly two and a half centuries, and in the same valley for hundreds of years before.

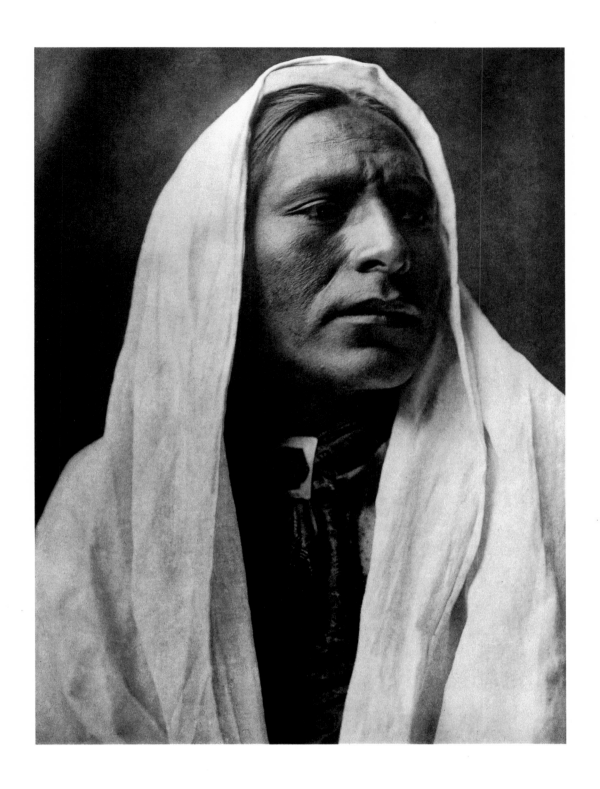

IĂHLA ("WILLOW") - TAOS, 1905

The name Taos is a Spanish plural, first recorded by Juan de Onate in 1598, of the Tewa name Ta-wii ("dwell gap"), which alludes to the situation of the village at the mouth of a cañon. Their own name for themselves is simply Taina ("people"), or specifically Iataina ("osier-willow people").

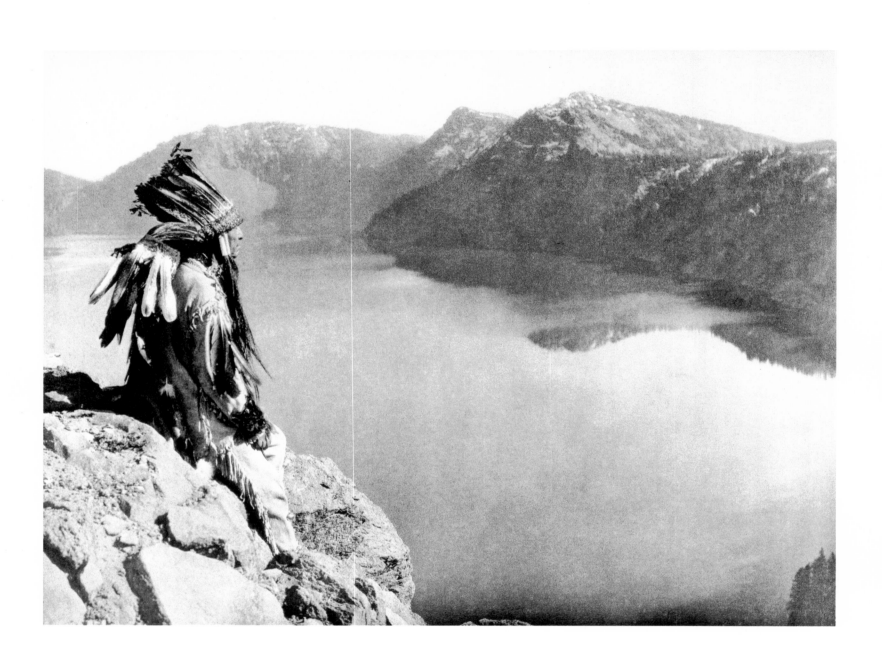

CRATER LAKE, 1923

A body of water indescribably blue, occupies an extinct crater in the heart of the Cascade Mountains of southern Oregon. It is on the boundary of what was formerly the territory of the Klamath Indians, who held it to be especially potent in conferring shamanistic power upon men who there fasted and bathed. An important Klamath myth seeks to account for the former absence of fish from Crater Lake, a condition that was altered in 1888 with the introduction of trout.

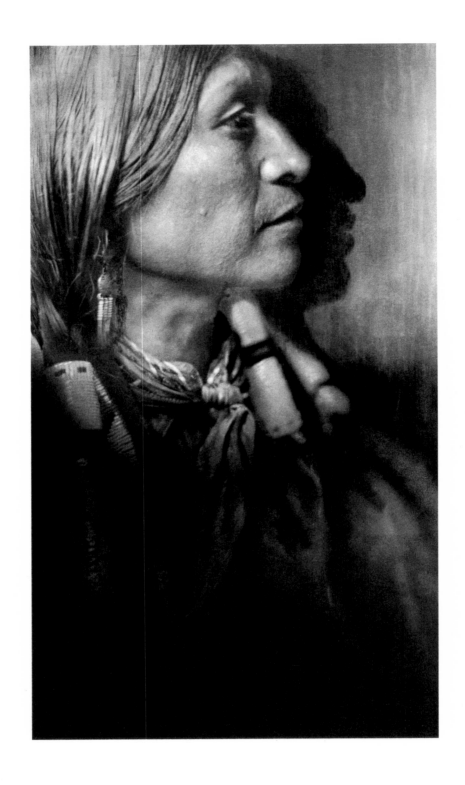

VASH GON - JICARILLA, 1904

The men wear their hair in braids hanging over the shoulders and wound with strips of deer-skin. Formerly they wore bangs in front on a line with the cheek-bones and tied their hair in a knot at the back of their head, as the Navaho and Pueblo Indians do.

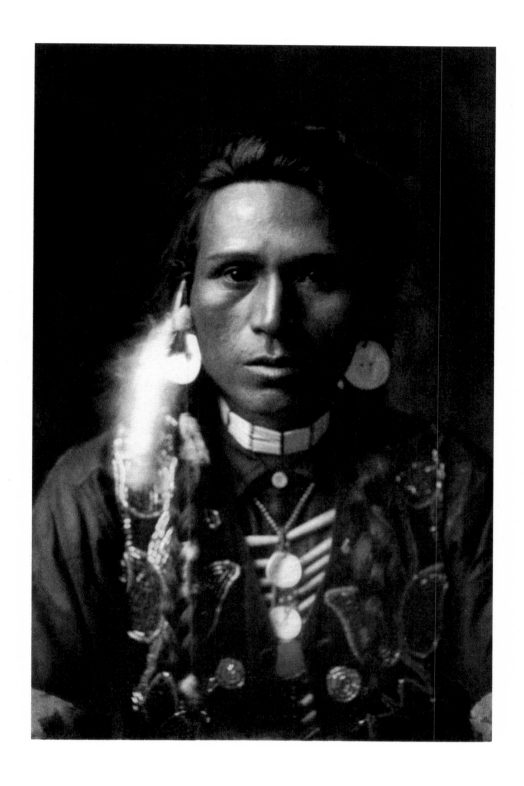

A YOUNG YAKIMA - YAKIMA, 1910

The reservation of Yakima rises from the level of the valley of Yakima River to the low range of mountains between that stream and the Columbia. In the glades of the mountains, small parties pitch their tipis in the spring time, and the women and girls gather edible roots, notably bitterroot.

CHIEF JOSEPH - NEZ PERCÉ, 1903

The name of Chief Joseph is better known than that of any other Northwestern Indian. To him, popular opinion has given the credit of conducting a remarkable strategic movement from Idaho to northern Montana in the flight of the Nez Percés in 1877. Their unfortunate effort to regain what was rightly their own makes an unparalleled story in the annals of the Indians' resistance to the greed of the whites. That they made this final effort is not suprising. Indeed, it is remarkable that so few tribes rose in the last struggle against such dishonest and relentless subjection.

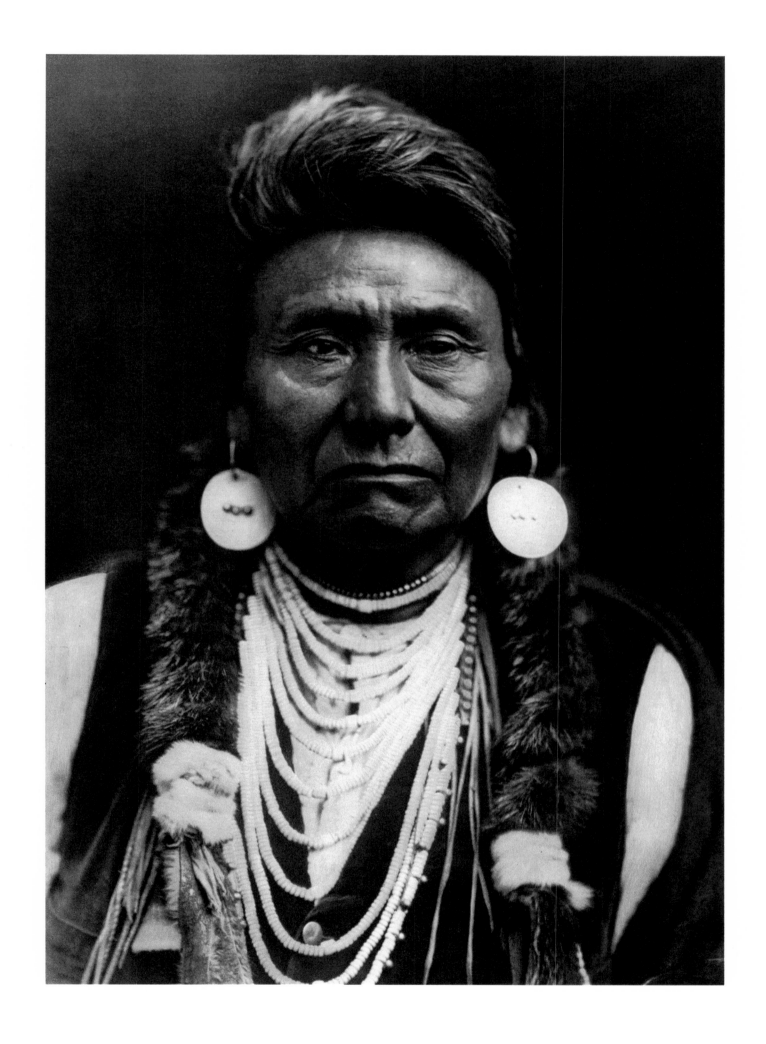

BLACK EAGLE - ASSINIBOIN, 1908

Born in 1834 on the Missouri below Williston, North Dakota. He was only thirteen years of age when he first went to war, and on this and on the next two occasions he gained no honors. On his fourth war excursion he was more successful, alone capturing six horses of the Yanktonai. While engaged in a fight with the Atsina near Fort Belknap, Montana, he killed a man and a boy. In a battle with the Yanktonai he killed one of the enemy, and in another repeated the former success. Black Eagle led war parties three times. He had a vision in which it was revealed to him that he would capture horses, and the vision was fulfilled. He had the same experience before he killed the man and the boy. He claims no medicine. Black Eagle married at the age of eighteen.

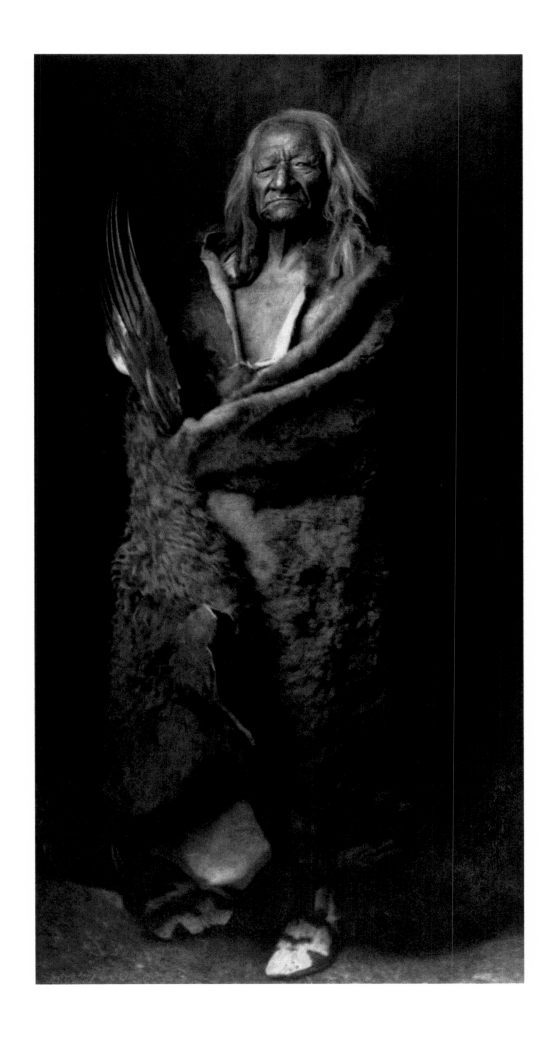

ASSINIBOIN HUNTER, 1926

The Assiniboin are an offshoot of the Yanktonai Sioux, from whom they separated prior to 1640. The southern branch were long confined on a reservation in Montana; the northern is resident in Alberta. The latter is divided into two bands, which formerly ranged respectively north and south of Bow River, from the Rocky Mountains out upon the prairies.

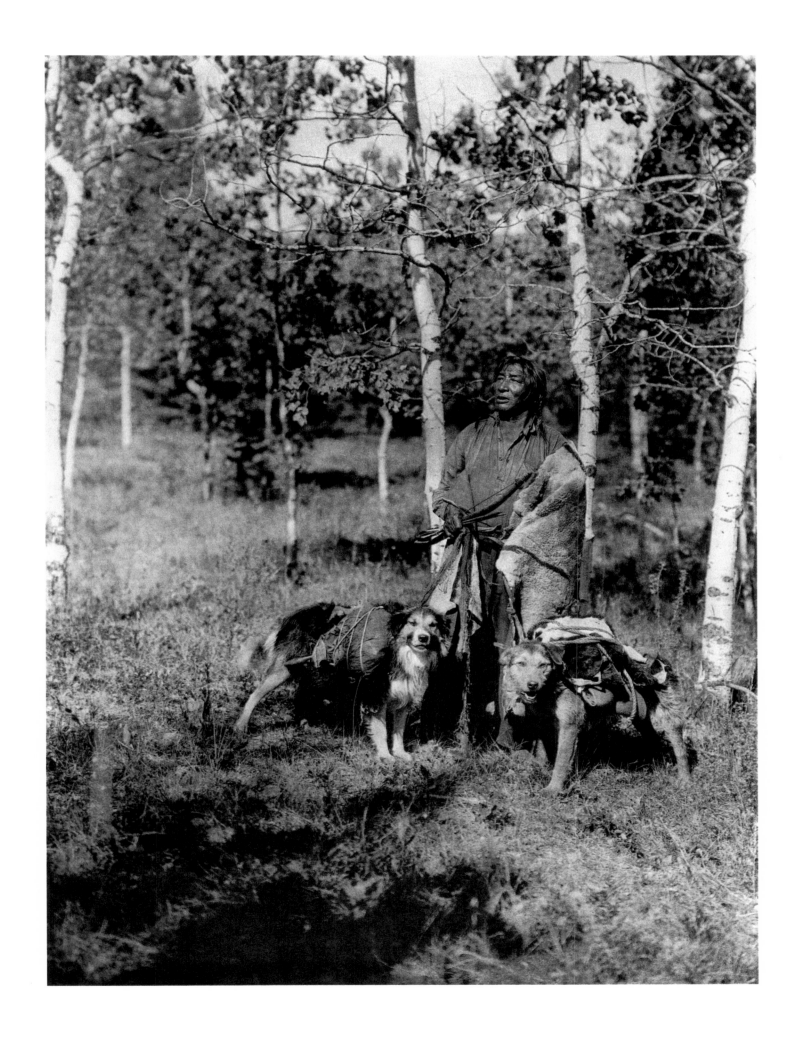

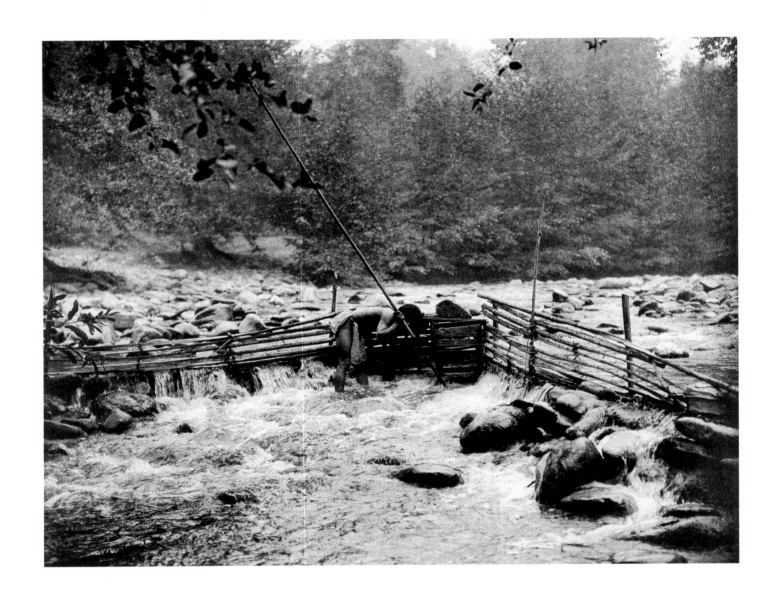

HUPA TROUT TRAP, 1923

Each fishing station was the hereditary possession of some family. Men who owned no station begged the use of one from those who were either weary of fishing or had enough fish for their immediate needs.

THE WHALER - MAKAH, 1915

Note the great size of the harpoon shaft. Indian whalers implanted the harpoon point by thrusting, not hurling the weapon.

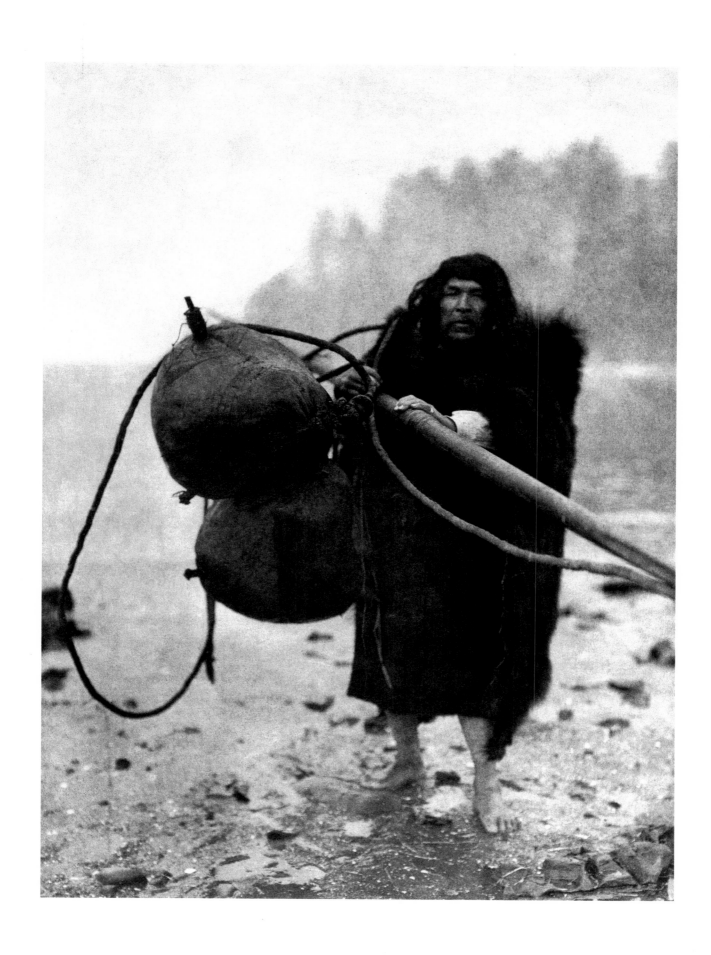

THE WHALER, 1915

A feat so remarkable as the killing of a whale with the means possessed by primitive men is inexplicable to the Indian except on the ground that the hunter has the active assistance of a supernatural being. Prayers and numerous songs form a part of every whaler's ritual. The secrets of the profession are handed down from father to son. But the most successful whalers are those who, even though they inherited the profession, have found an object which represents the supernatural whale. This object is either a double-headed, black worm eleven inches long and an inch and a half thick, or a certain species of crab.

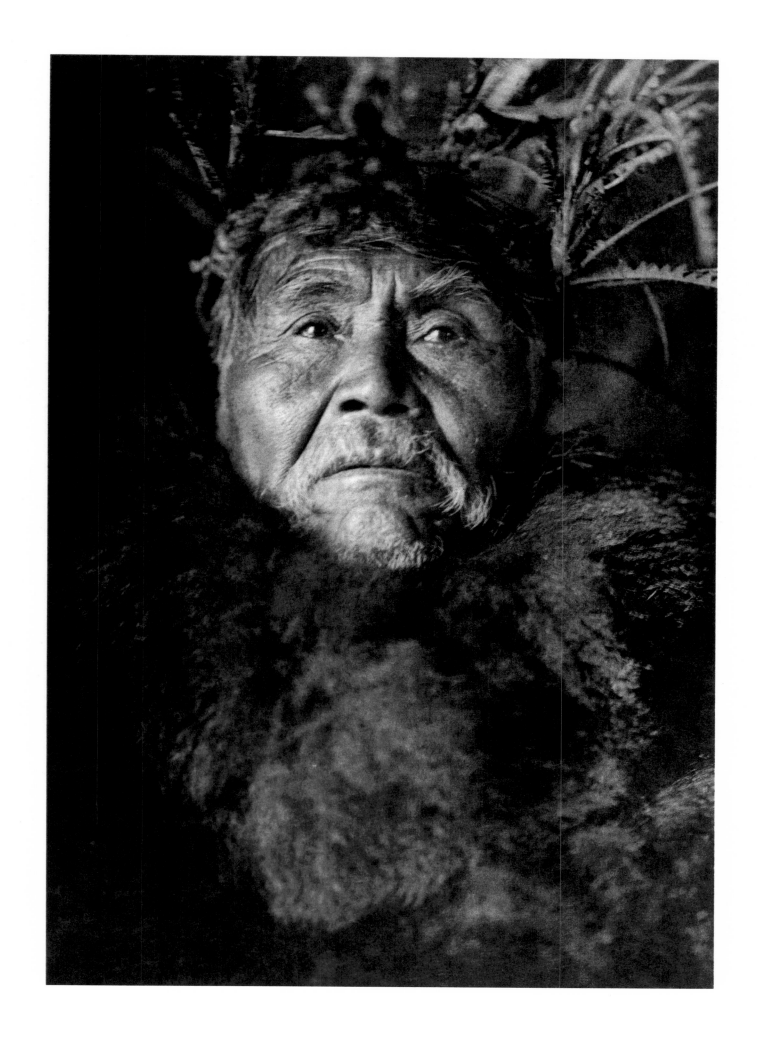

APACHE BABE, 1903

A fortunate child picture, giving a good idea of the happy disposition of Indian children, and at the same time showing the baby carrier or holder.

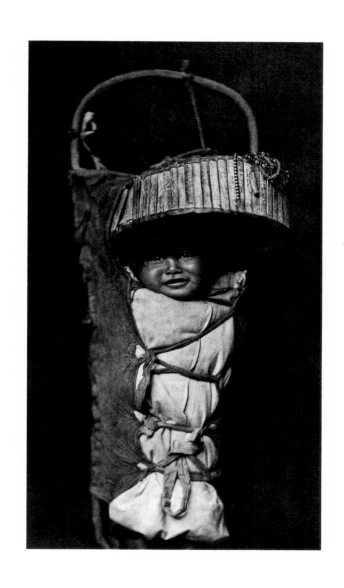

NUNIVAK MOTHER AND CHILD, 1928

Children and adults alike of the Alaskan Nunivak Eskimo group are healthy, as a rule, and exceptionally happy because they have been little affected with civilization. The Nunivak populate a bleak, rocky and treeless island near the Yukon. They live mostly on the shore moving from one place to another to take advantage of the fish runs and the varying seasons As soon as a child is born, a small fire is lighted in the parents' home and the baby is bathed in a wooden dish. After bathing, it is kept rolled up in a parka until the navel is healed. The baby is named while still in the parka. The most common practice is to give the infant the name of the most recently deceased relative, in order that the name may remain in the family and not be forgotten. Sometimes the name of the most recently deceased person in the village is given. A person with no relatives in order to perpetuate his name will ask the parents' permission to have the baby named after him.

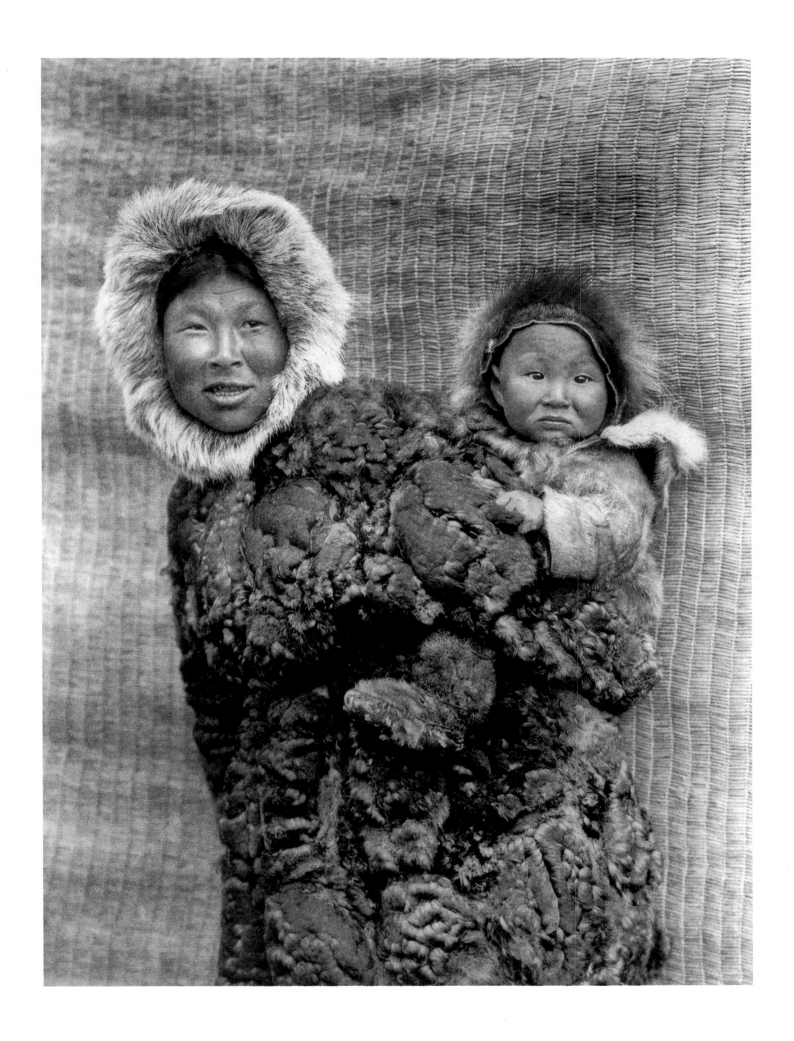

^I FLATHEAD MOTHER AND CHILD, 1910

Children were named a few days after birth, usually by the father or the grandfather, in the presence of family and relations. The name chosen was often that of an ancestor or a well-known personage. Since a name was regarded as a part of an individual, it could not be given to a child or assumed by an adult without his permission. A "good" name – one believed to be capable of bringing its bearer good fortune – sometimes was sold for as much as a horse.

^{II} SIOUX MOTHER AND CHILD, 1905

When a child was born, the parents prepared a feast and sent for the medicine man, asking him to name the infant. The name bestowed was always one suggested by some animal or object seen during one of his fasts, and the accompanying prayer was one taught him during a vision. After a boy returned from his first war-party, he was given an appellation by an uncle or a brother-in-law, and this was later exchanged for a name earned by great deeds. A man could assume his father's name only after having performed acts of such valor as to entitle him to the honor.

^{III} APSAROKE MOTHER AND CHILD, 1908

On the fourth day after the birth of a child a man of prominence, or in some instances a woman, was called to bestow a name, which, as a rule, was one that he had heard called among the spirit-people in one of his visions, or perhaps one referring to some great deed of his own. Incense was made, and the child raised four times in the cloud of smoke to symbolize the wish that it might grow tall and vigorous.

^{IV} HOPI MOTHER AND CHILD, 1921

On the twentieth day after birth, each of the mother's clanswomen takes to the godmother a basket of meal and some mutton, which they have prepared the previous day; and at the same time the father's clanswomen assemble at his house, each bringing some small present for the child, and bestowing on it one of the names that belong to their clan. A Hopi name therefore does not refer to the clan totem of the bearer. From all these names one stands forth prominently, and this is the one adopted for the child. But sometimes a woman expresses the desire to have her child, as yet unborn, named by a woman of some other clan than that of her husband.

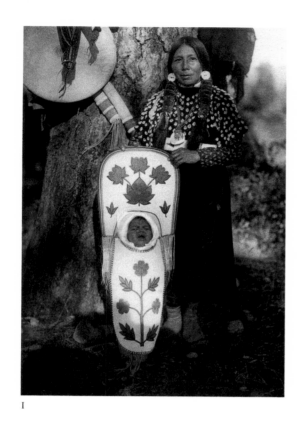

I

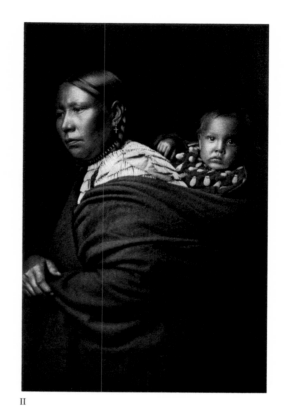

II

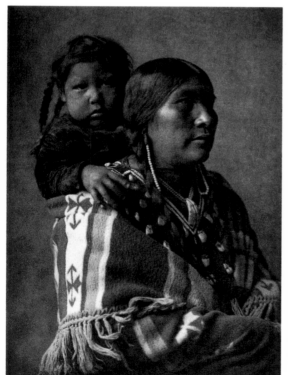

III

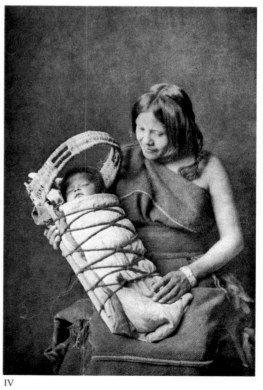

IV

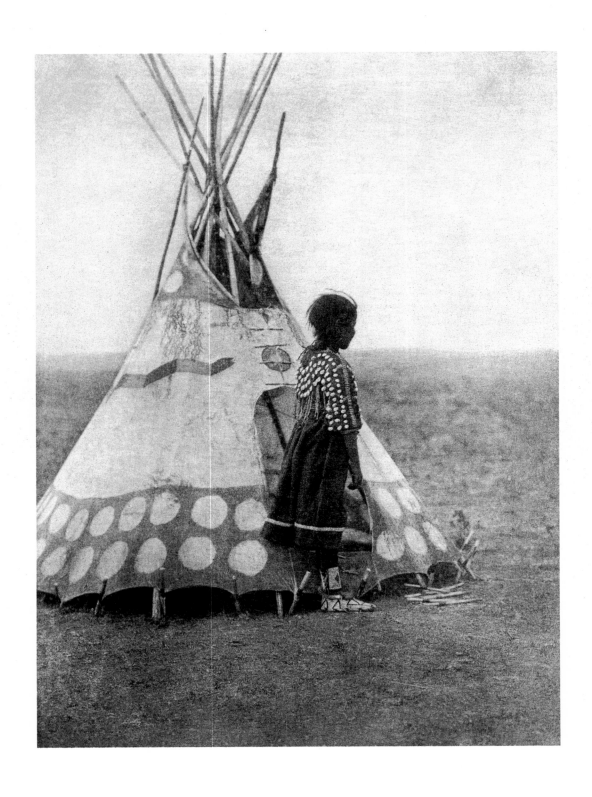

A PIEGAN PLAY TIPI, 1926

Since the times of the earliest traditions the buffalo-skin tipi has been used by the Piegan. The tipi of the old days, when dogs were beasts of burden, was smaller than during the period following the coming of the horse. The covering was of tanned buffalo-hides, and when new was almost white; but with use and from the smoke of the tipi fire it became a rich brown, and was exceedingly soft and flexible. To make a small tipi required six or seven hides.

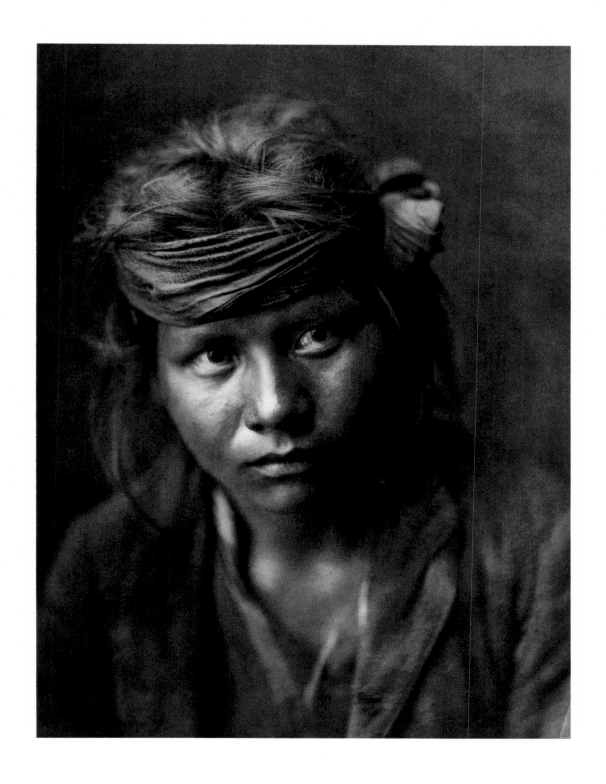

A SON OF THE DESERT - NAVAHO, 1904

In the early morning, this boy, as if springing from the earth itself, came to the author's desert camp. Indeed, he seemed a part of the very desert. His eyes bespeak all the curiosity, all the wonder of his primitive mind striving to grasp the meaning of the strange things about him.

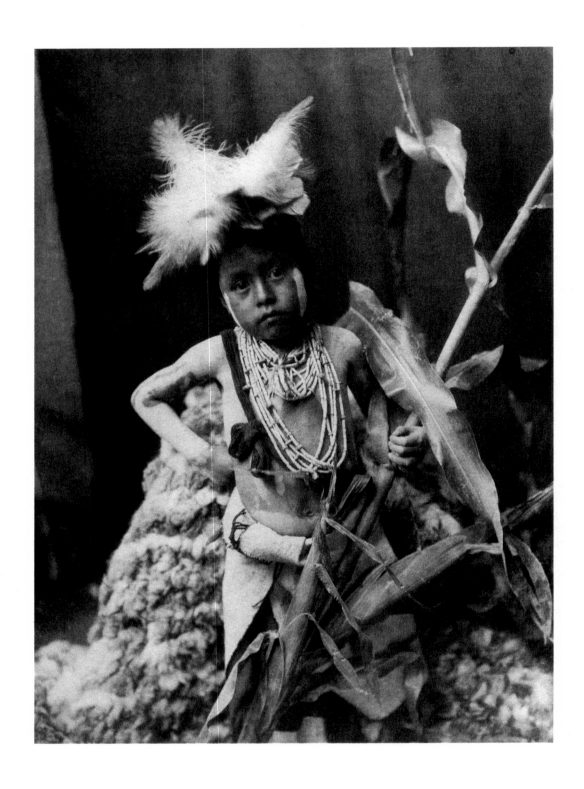

AWAITING THE RETURN OF THE SNAKE RACERS -
HOPI, 1921

At all times, Hopi children were admonished not to crowd too closely to the fire, and not to eat too much, and constant watch was kept to see that they observed this latter injunction. Daily they were made to practice running, boys of five or six years doing their mile every morning. This Spartan training was intended to render the children capable of resisting the Navaho and other hostile tribes and untiring in hunting. At night when the elders were talking, boys were told to listen carefully and if any manifested a desire to sleep he was sent outside to "breathe the spirit of the stars."

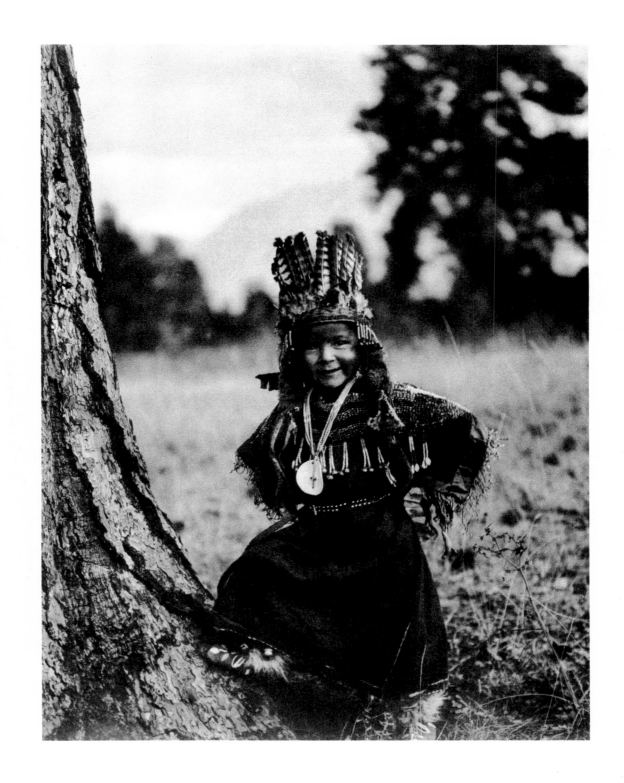

FLATHEAD CHILDHOOD, 1910

Through annual incursions into the buffalo plains east of the Rocky Mountains, the Flatheads adopted much of the Plains culture. Not only their domicile (tipi), their garments, weapons, and articles of adornment, came from this source, but many of their dances were in imitation of similar ceremonies practiced by the Prairie tribes.

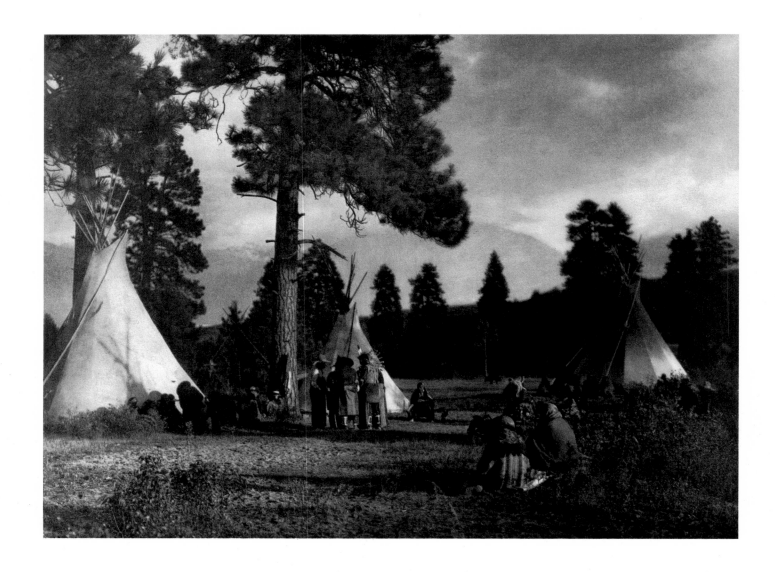

FLATHEAD CAMP ON THE JOCKO RIVER, 1910

This scene depicts a small camp among the pines on the reservation of the Flatheads in western Montana, the majestic Rocky Mountains rising abruptly in the background.

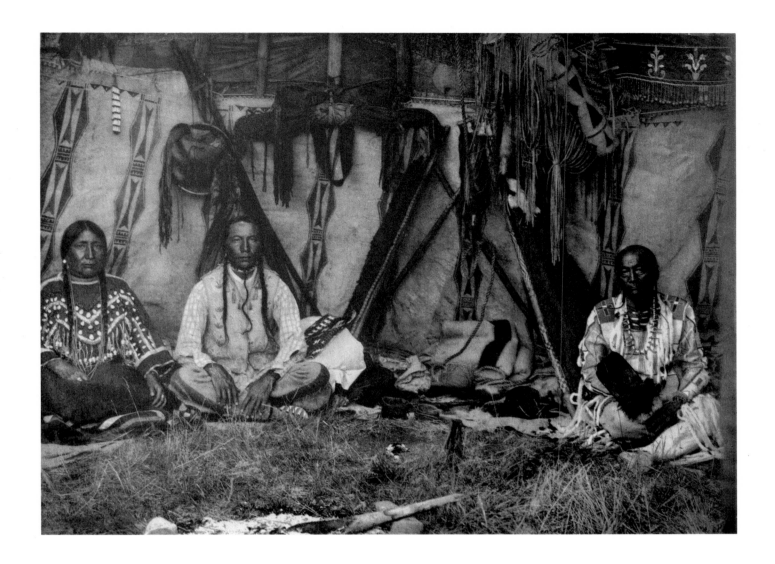

LODGE INTERIOR - PIEGAN, 1911

The picture is full of suggestion of the various Indian activities. In a prominent place lie the ever-present pipe and its accessories on the tobacco cutting-board. From the lodge-poles hang the buffalo-skin shield, the long medicine bundle, an eagle-wing fan and deerskin articles for accoutering the horse. The upper end of the rope is attached to the intersection of the lodge-poles, and in stormy weather the lower end is made fast to a stake near the center of the floor space.

BEAR'S BELLY - ARIKARA, 1908

Born in 1847 at Fort Clark in the present North Dakota. He had no experience in war when at the age of nineteen he joined Custer's scouts at Fort Abraham Lincoln, having been told by old men of the tribe that such a course was the surest way to gain honors. Shortly after his arrival, Custer led a force into the Black Hills country; on the other side of the divide there was a slight encounter with five tipis of the Sioux, in the course of which, the young Arikara counted two first coups and one second. Bear's Belly fasted once. Going to an old man for advice, he was taken to the outskirts of the village to an old buffalo skull, commanded to strip, smear his body with white clay, and sit in front of the skull. When he had taken the assigned position, the old man held up a large knife and an awl while he addressed the buffalo skull: "This young man sits in front of you, and is going to endure great suffering. Look upon him with great favor, you and Neshanu, and give him a long, prosperous life." With that he cut pieces of skin from the faster's breast and held them out to the buffalo skull. Bear's Belly married at the age of nineteen. He became a member of the Bears in the medicine fraternity and relates the following story of an occurrence connected with that event:

"Needing a bearskin in my medicine-making, I went, at the season when the leaves were turning brown, into the White-Clay hills. All the thought of my heart that day was to see a bear and kill him. I passed an eagle trap, but did not stop: it was a bear I wanted, not an eagle. Coming suddenly to the brink of a cliff I saw below me three bears. My heart wished to go two ways: I wanted a bear, but to fight three was hard. I decided to try it, and, descending, crept up to within forty yards of them, where I stopped to look around for a way of escape if they charged me. The only way out was by the cliff, and as I could not climb well in moccasins I removed them. One bear was standing with his side toward me, another was walking slowly toward him on the other side. I waited until the second one was close to the first and pulled the trigger. The farther one fell; the bullet had passed through the body of one and into the brain of the other. The wounded one charged, and I ran, loading my rifle, then turned and shot again, breaking his backbone. He lay there on the ground only ten paces from me and I could see his face twitching. A noise caused me to remember the third bear, which I saw rushing upon me only six or seven paces away. I was yelling to keep up my courage and the bear was growling in his anger. He rose on his hindlegs, and I shot, with my gun nearly touching his chest. He gave a howl and ran off. The bear with the broken back was dragging himself about with his forelegs, and I went to him and said, 'I came looking for you to be my friend, to be with me always.' Then I reloaded my gun and shot him through the head. His skin I kept, but the other two I sold."

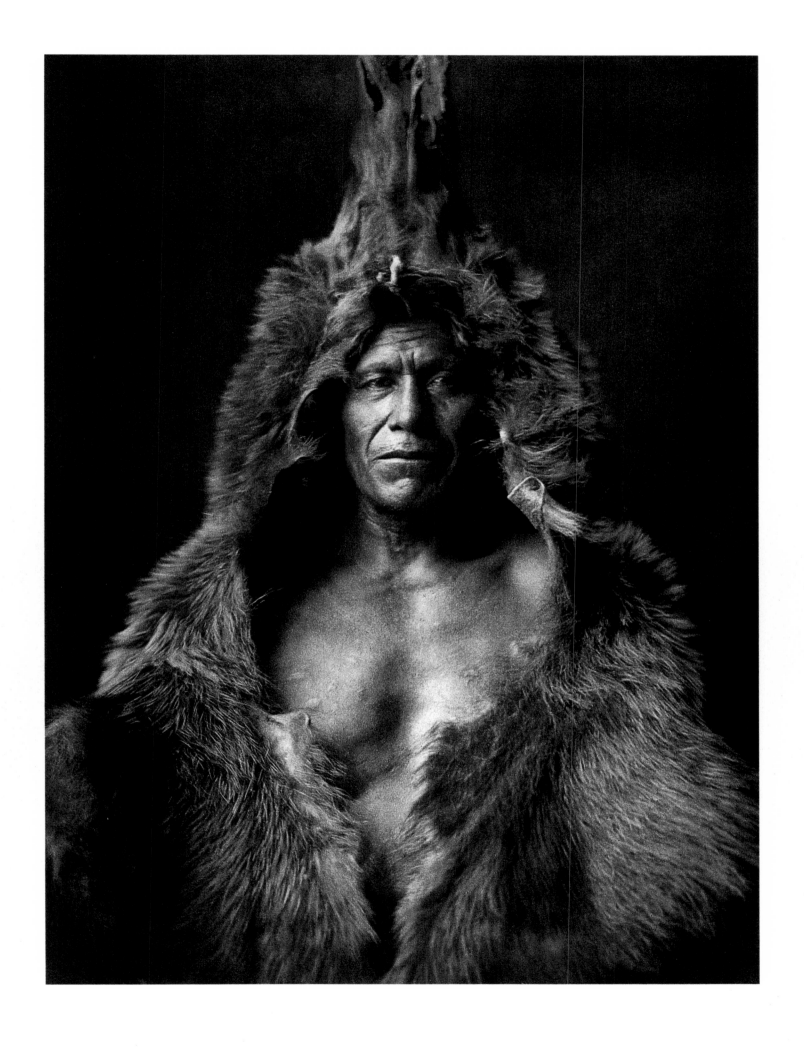

TEARING LODGE - PIEGAN, 1910

Pinokiminŭksh is one of the few Piegan of advanced years and retentive memory. He was born about 1835 on Judith River in what is now northern Montana, and was found to be a valuable informant on many topics. The buffalo skin cap is a part of his war costume, and was made and worn at the command of a spirit in a vision.

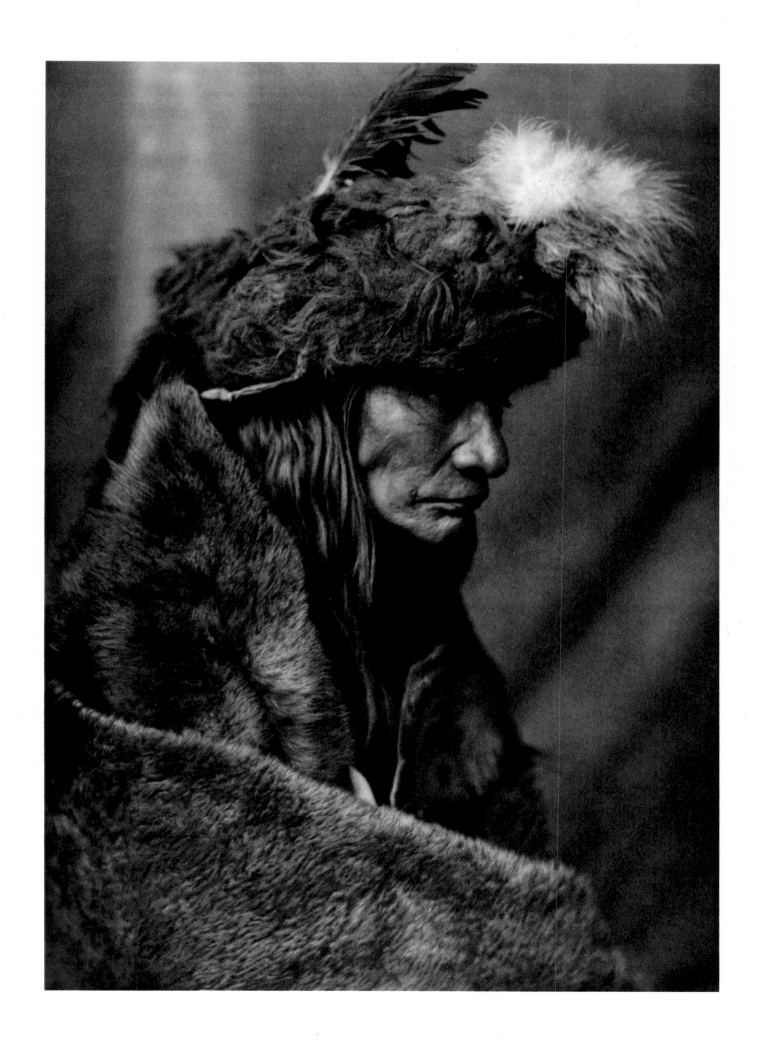

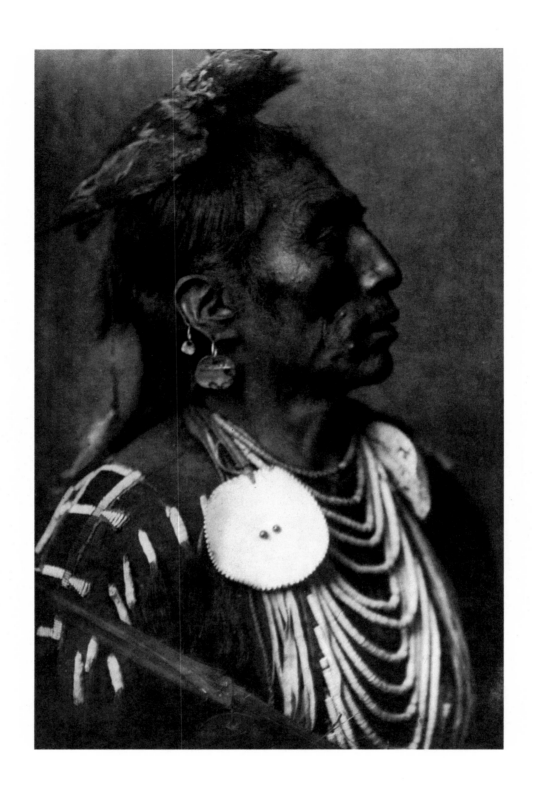

MEDICINE CROW - APSAROKE, 1908

Born 1848. Mountain Crow; member of the Newly Made Lodge clan and of the Lumpwood organization. At eighteen he fasted four days and three nights, and on the morning of the fourth day a spirit resembling a white man appeared and foretold the passing away of the buffalo and the coming of many white men with cattle, horses, and steamboats. His medicine of hawk was purchased from another man. Counted three first coups, captured five guns and two tethered horses, and led ten successful war parties. In a fight with the Nez Percés he killed a warrior, counted first coup upon him, and captured his gun – two regular honors at one time, besides the distinction of killing an enemy. This act he twice repeated in battles with the Arapaho and the Sioux. Twice he fought on the side of the white men when "their flag was on the ground": once against the Nez Percés in Chief Joseph's retreat, and again under General Crook when the Sioux under Sitting Bull were fleeing across the Canadian border. Medicine Crow participated in ten severe fights, killed three men, had two horses shot from under him, and the distinction of having "thrown away" six wives. The hawk fastened on the head is illustrative of the manner of wearing the symbol of one's tutelary spirit.

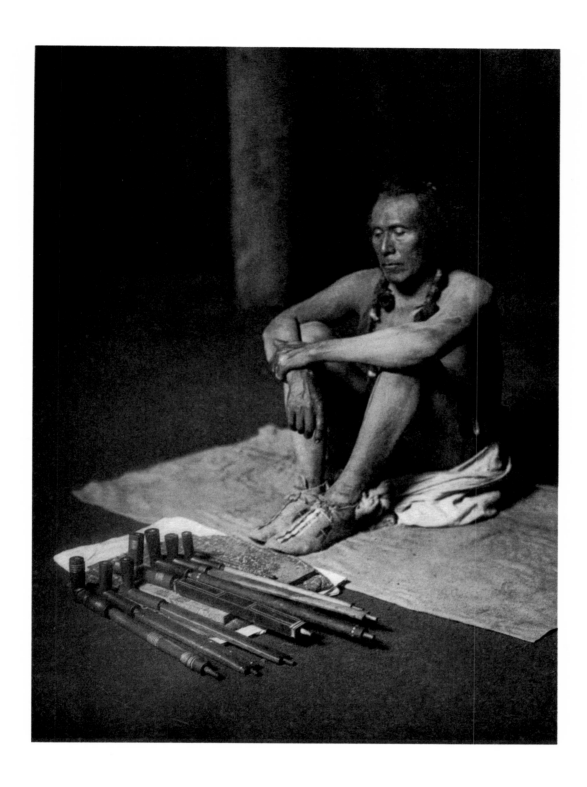

IN THE MEDICINE LODGE - ARIKARA, 1908

Any tribe living in permanent villages was apt to develop in its religious ceremonies an elaborateness that found expression both in esoteric performances and in those designed more or less for the entertainment of the people. As distinguished from the practices of charlatans, common to many tribes, the so-called medicine rites were all of a religious character.

The Arikara developed the legerdemain of their all-summer medicine ceremony to such an extent that other tribes, far and near, learned of their wonderful and potent magic. The superstition and credulity of the Indian are such that medicine-men living afar, as well as the tribesmen of the performers, believed these tricks to be the mysterious acts of supernatural powers.

DANCING TO RESTORE AN ECLIPSED MOON
QÁGYUHL, 1914

It is thought that an eclipse is the result of an attempt of some creature in the sky to swallow the luminary. In order to compel the monster to disgorge it, the people dance round a smouldering fire of old clothing and hair, the stench of which, rising to his nostrils, is expected to cause him to sneeze and disgorge the moon.

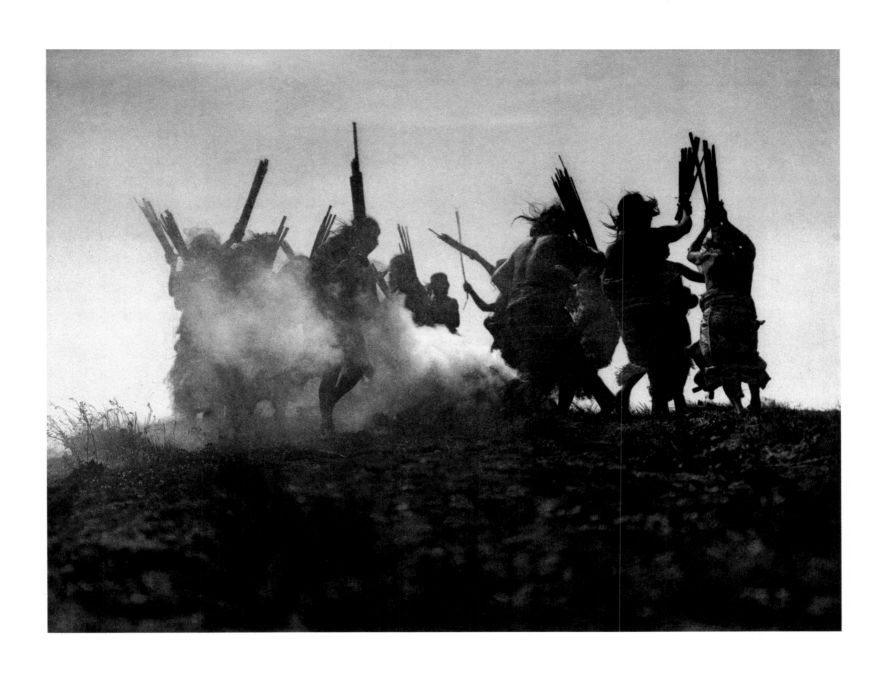

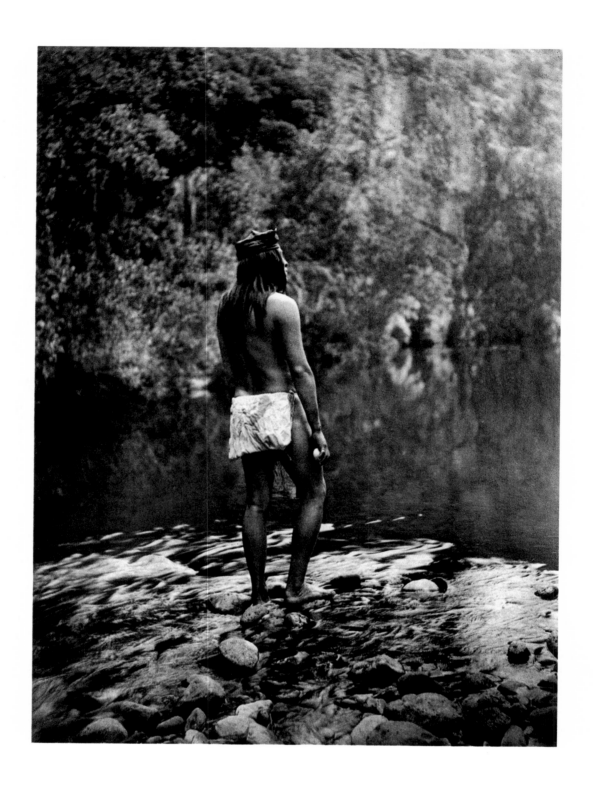

THE APACHE, 1906

A young man at a spot on the Black River, Arizona, where the dark, still pool breaks into the laugh of the rapids Because of the Apache's cunning, his fearlessness, and his long resistance to subjection both by the missionary and by the governments under whose dominion he has lived but until recent times never recognized, the Apache, in name at least, has become one of the best known tribal groups.

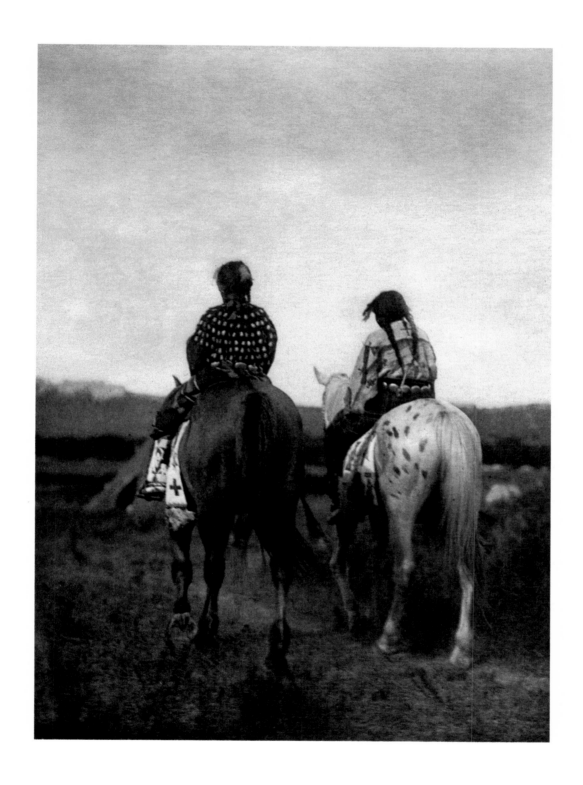

DAUGHTERS OF A CHIEF · SIOUX, 1907

As a rule the women of the plains tribes are natural horsewomen, and their skill in riding is scarcely exceeded by that of the men. As mere infants they are tied upon the backs of trusty animals, and thus become accustomed to the long days of journeying. The Sioux are a semi-nomadic people, and no tribe which the writer has studied is so lacking in traditional knowledge of its original home and early migration.

LUMMI TYPE - LUMMI, 1899

The Lummi held considerable territory in the vicinity of Lummi Bay, Washington, as well as many of the San Juan islands. Early in the eighteenth century the Lummi sought to expand their territory beyond the San Juan islands towards the Nooksack River where the fishing was good. This resulted in a long and bloody war with the Skolahun tribe which ended in their extermination. The principal warrior of the Lummi, Shalakst, heard that a few Skalahun families still lived on Nooksack River. He ordered his men to attack and kill them while they fished on the river. The victims were so fearful and begged so servilely for mercy that Shalakst agreed to let them live. The Lummi took possession of the Skolahun territory and swayed by gifts and woman, they let the few surviving people live and marry among them.

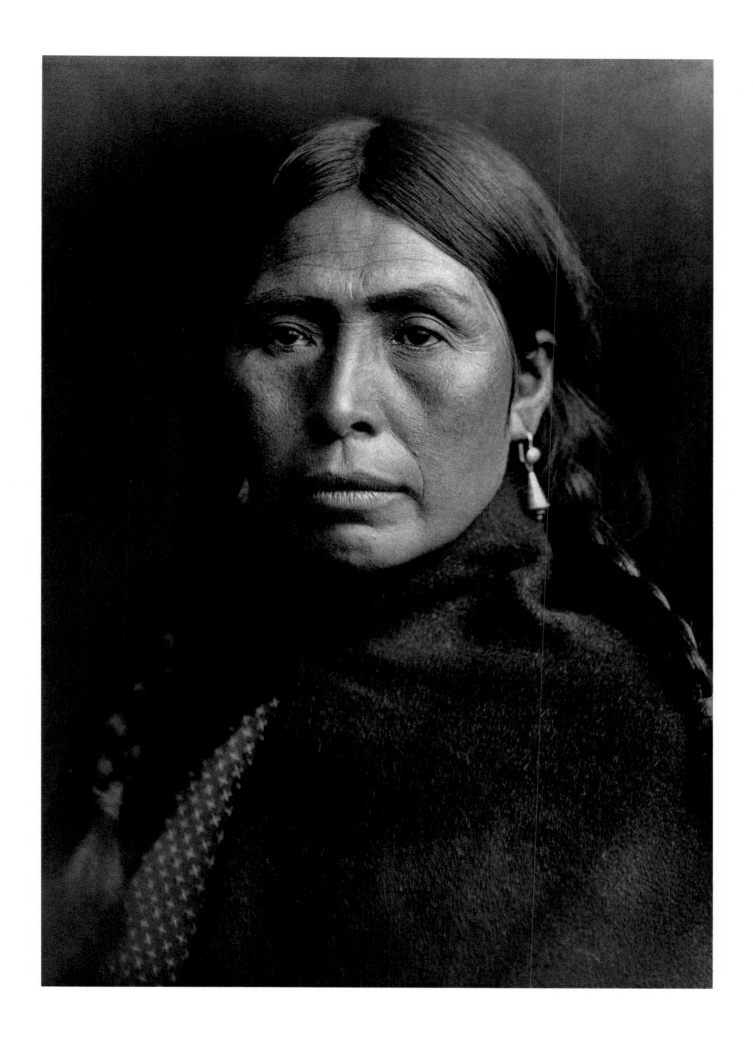

TWO BEAR WOMAN - PIEGAN, 1911

One constantly working with Indians is forcefully impressed with the slight superficial differ-entiation in the sexes, the women looking quite masculine. This is of course natural to all tribes, and in fact to all primitive people, in as much as there have been no ages of shielding and protecting of the females; but rather in their life the women have to meet their full share of physical exertion and hardship.

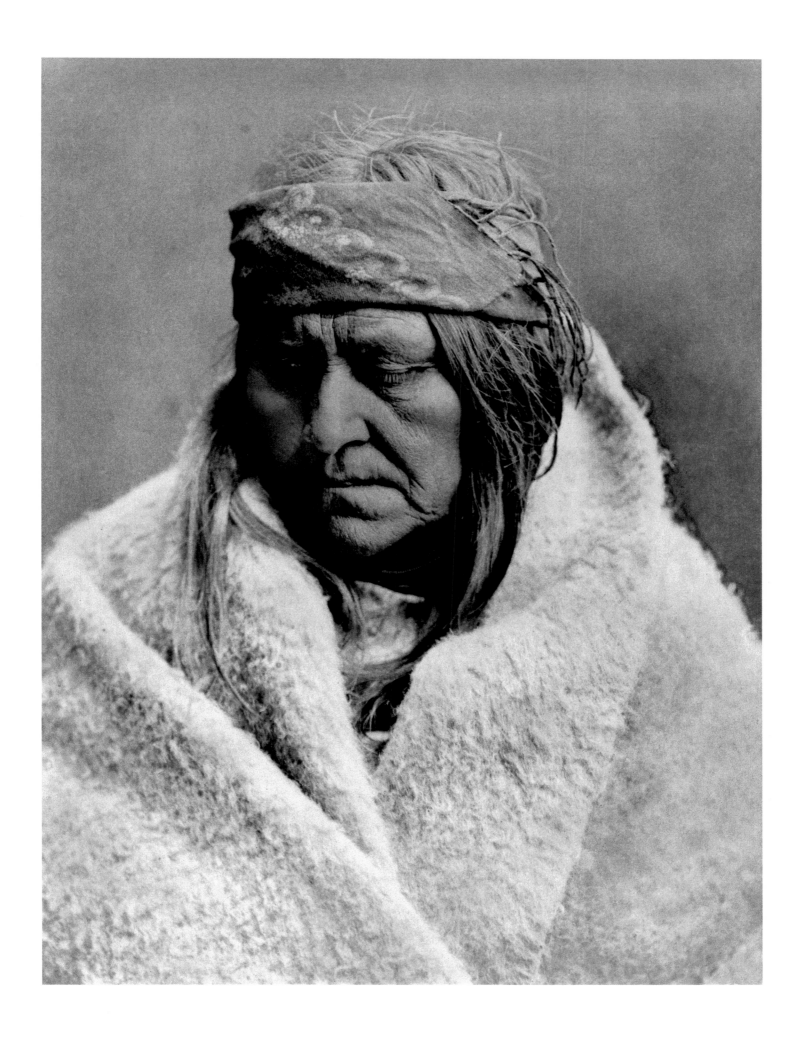

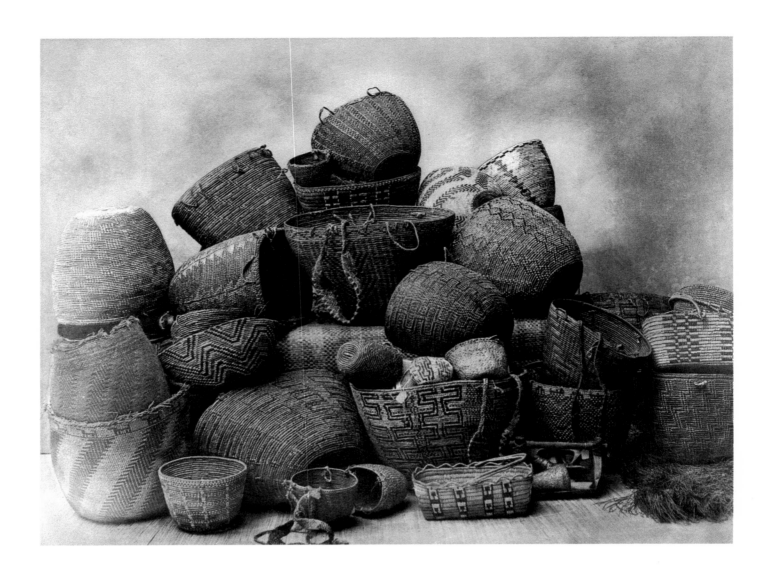

PUGET SOUND BASKETS - PUGET, 1912

Basketry continues to be an important industry of many Puget Sound tribes, the bulk of the product passing into the hands of dealers. Women of the Skokomish band of Twana are especially skillful in weaving soft, flexible baskets.

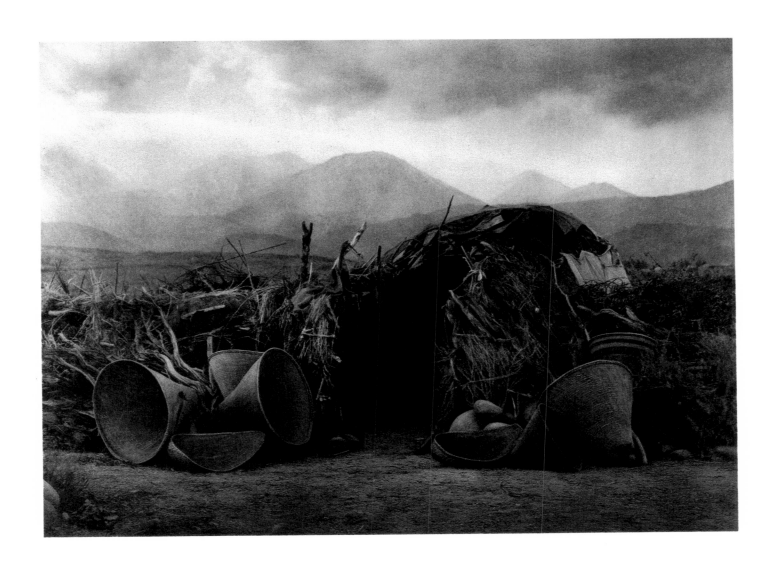

A MONO HOME · MONO, 1924

The Mono inhabit east-central California from Owens Lake to the head of the southerly afflu-
ents of Walker River. The snow-capped Sierra Nevada rises abruptly on the western border of
this inland basin. The wickiup shown in the plate is a typical winter shelter, and the utensils
are burden-baskets and sieves, or winnowing trays.

THE PIKI MAKER - HOPI, 1906

Piki is corn bread baked in colored sheets of paper-like thinness. The batter is spread on the baking stone with the bare hand, and the quickly baked sheet is folded and laid on the basket at the baker's left.

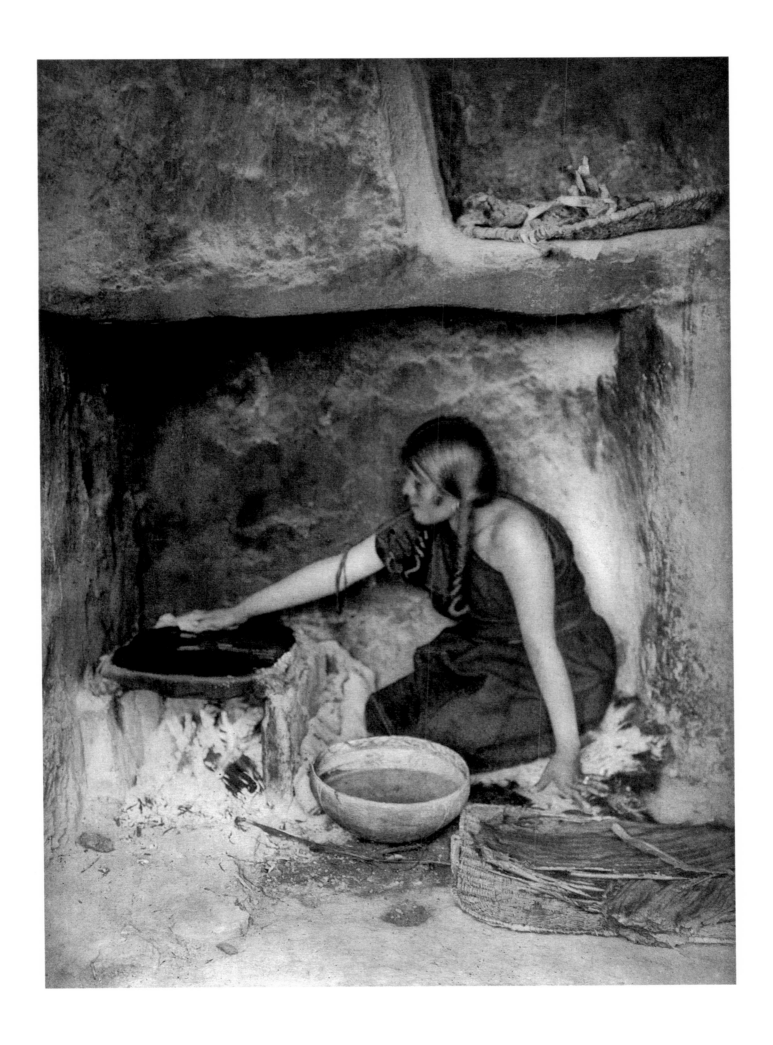

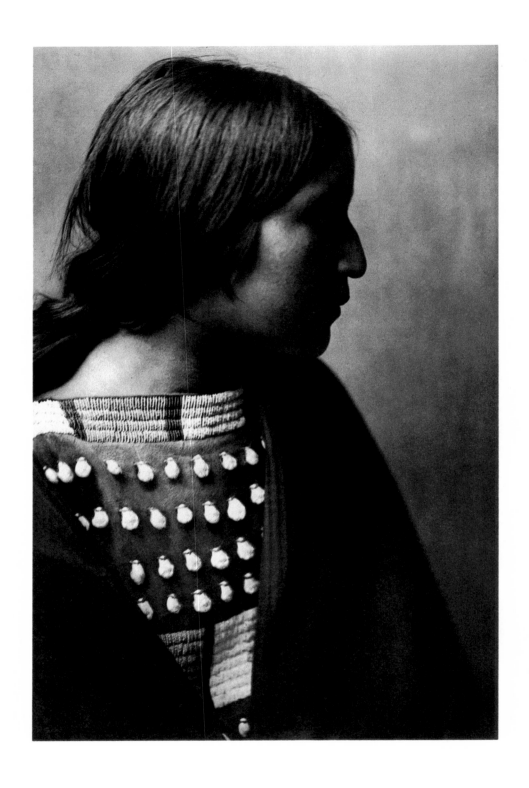

ARIKARA GIRL, 1908

A young Arikara woman in a dress made entirely of deerskin, embroidered with beads and porcupine quills.

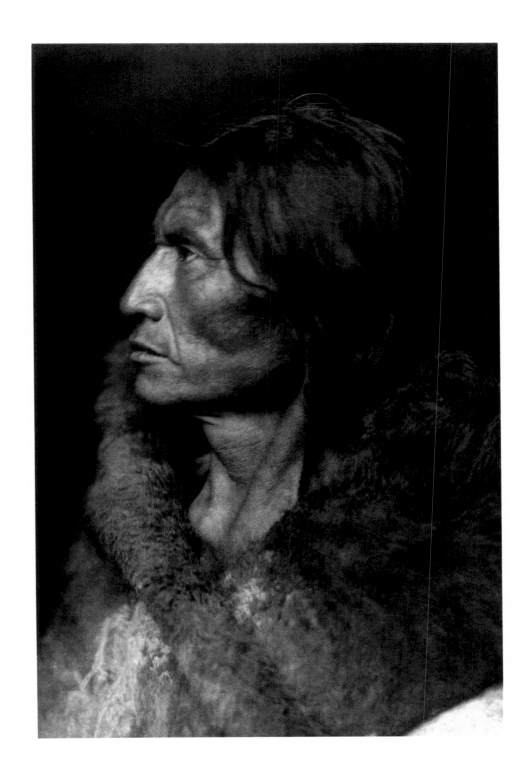

MOSQUITO-HAWK - ASSINIBOIN, 1908

Born on the Missouri below Williston, North Dakota. When he was fourteen he followed a war party, but gained no honors. On his next four expeditions he had as little success, but on the next he killed a Sioux. He fought against the Piegan, killing two, taking a scalp, and counting a first coup. In another battle with the Piegan he killed one, counted coup, and took a scalp. He never fasted, and never has had a vision. He married at seventeen.

THE SCOUT, APACHE, 1906

Ever the scourge of peaceable Indians that dwelt in adjacent territory, and for about three hundred years a menace to the brave colonists that dared settle within striking distance of him, the Apache of Arizona and New Mexico occupied a region that long remained a terra incognita, while the inner life of its occupants was a closed book.

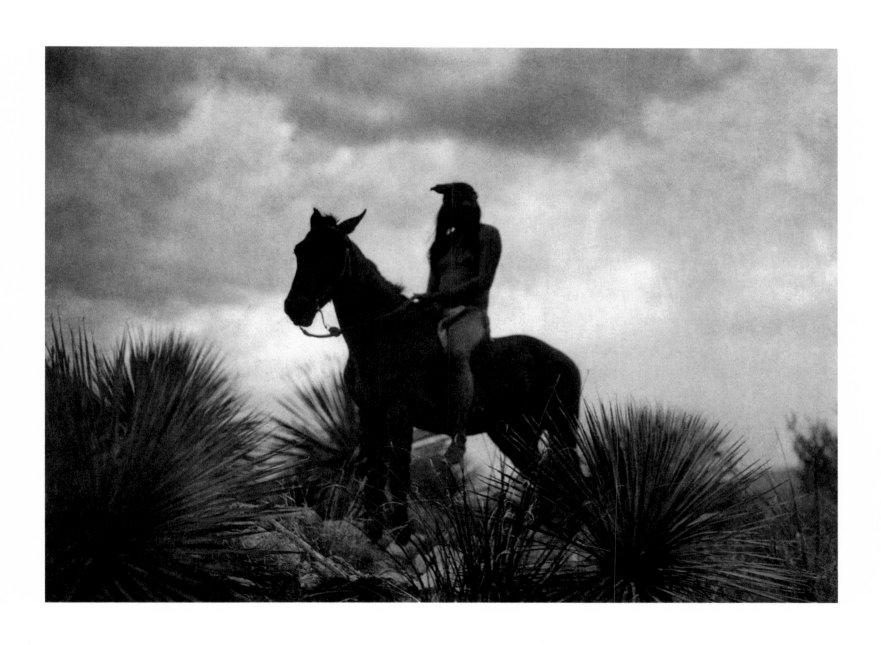

THE VANISHING RACE - NAVAHO, 1904

The thought which this picture is meant to convey is that the Indians, as a race, already shorn of their tribal strength and stripped of their primitive dress, are passing into the darkness of an unknown future. Feeling that the picture expresses so much of the thought that inspired the entire work, the author chose it as the first of the original series.

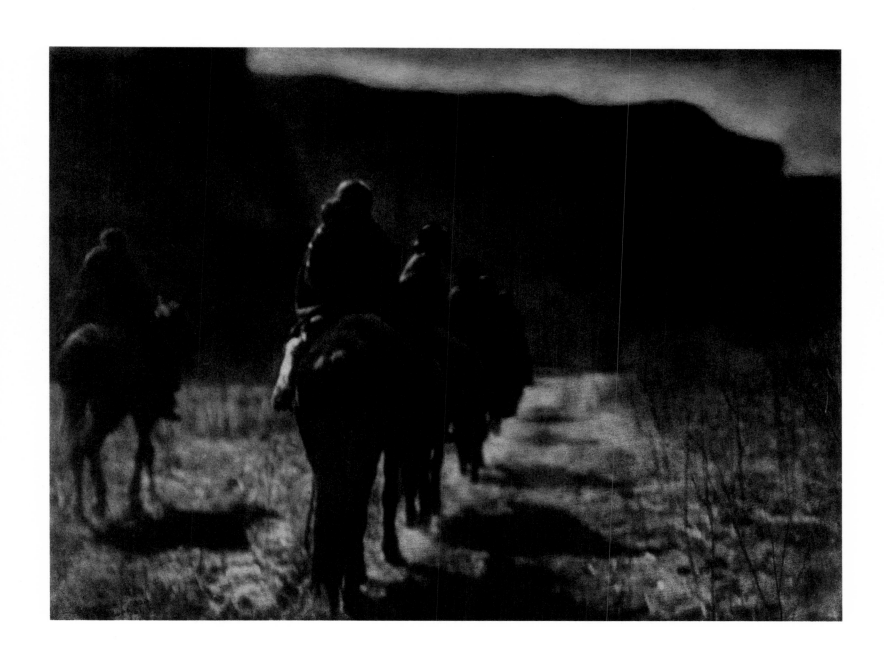

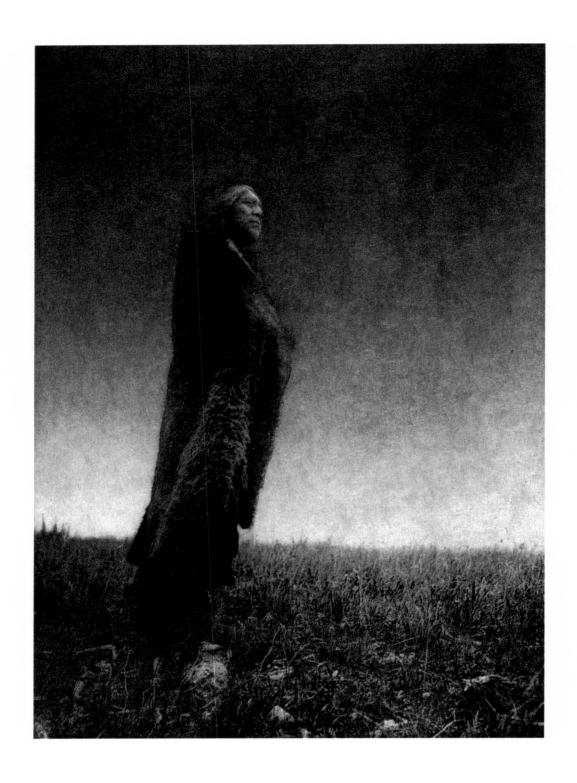

CRYING TO THE SPIRITS - HIDATSA, 1908

The Hidatsa, commonly known under the inappropriate appellation "Gros Ventres of the Missouri," differed from most of the tribes of the northern plains in that they were a sedentary and semi-agricultural people, gaining their livelihood, of course, by the chase. Their habitat for many generations has been along the Missouri from Heart River to the Little Missouri, in North Dakota. According to legend, their emergence was a mythical one from the underworld.

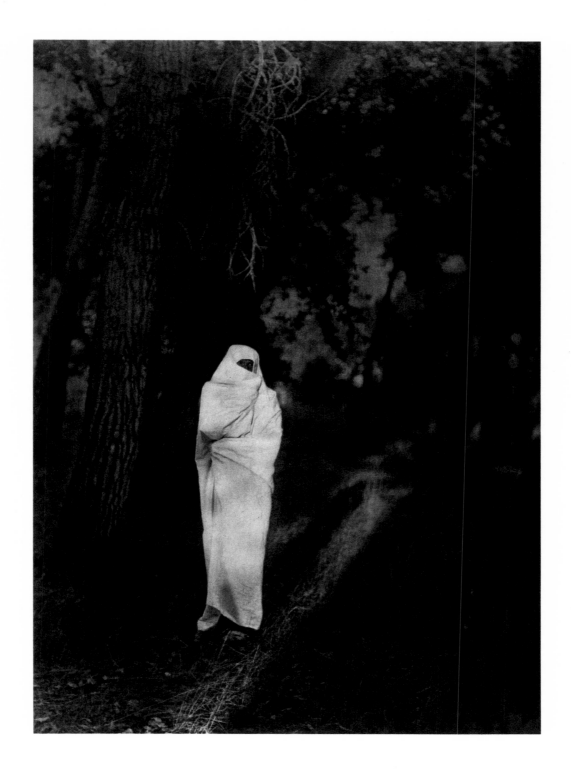

WAITING IN THE FOREST - CHEYENNE, 1910

At dusk in the neighborhood of the large encampments, young men, closely wrapped in non-committal blankets of white cotton sheets, may be seen gliding about the tipis or standing motionless in the shadow of trees, each one alert for the opportunity to steal a meeting with his sweetheart. The Cheyenne belong to the Algonquian linguistic family and therefore are related to the tribes of the Blackfoot Confederacy and to the Arapaho of the north, and, much more remotely, to many of the tribes that once lived along the Atlantic seaboard and in the Midwest. They are divided into the Northern Cheyenne, living in Montana, and the Southern Cheyenne who were assigned a reservation in Oklahoma in 1867.

AT THE TRYSTING PLACE - HOPI, 1921

Soft, regular features are characteristic of Hopi young women, and no small part of a mother's time used to be devoted to dressing the hair of her unmarried daughters. The arrangement imitates the squash blossom and indicates virginity.

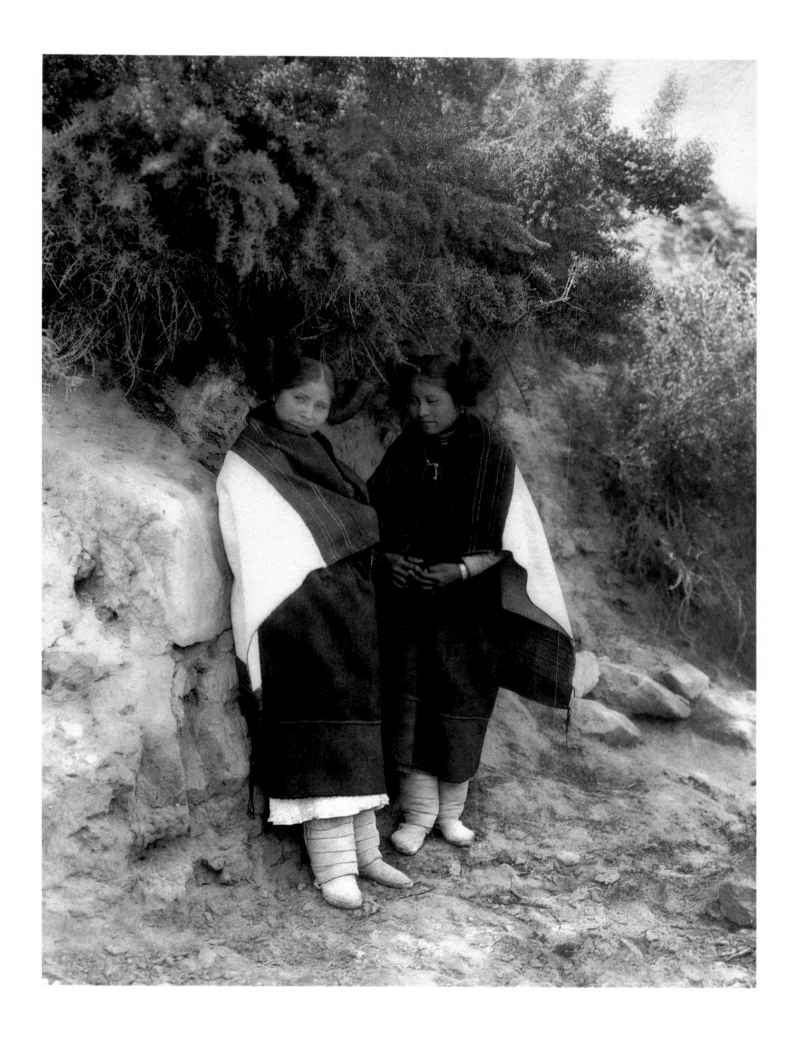

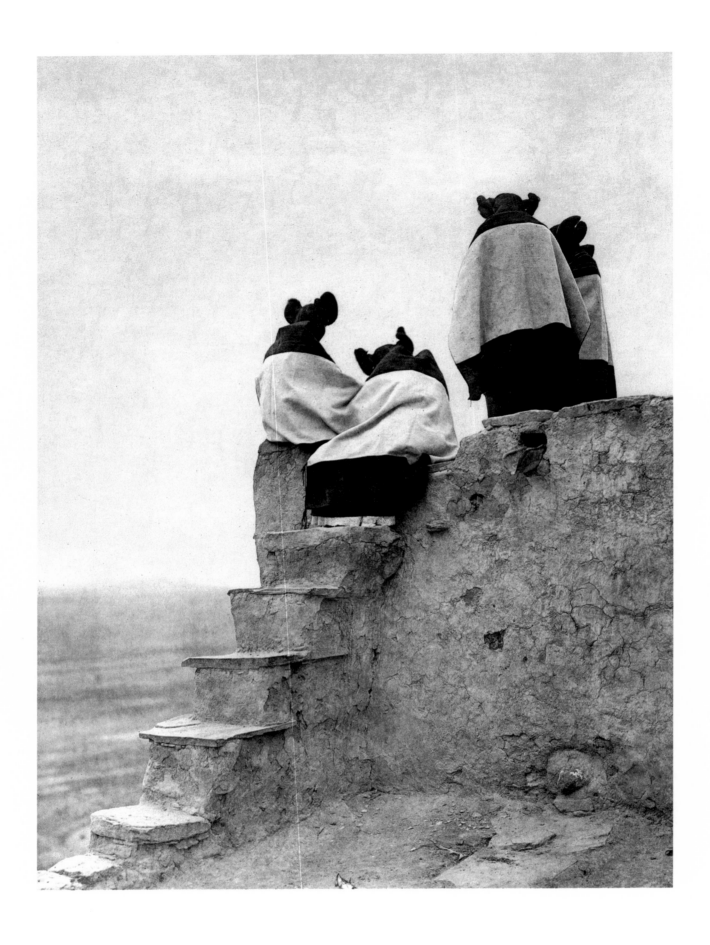

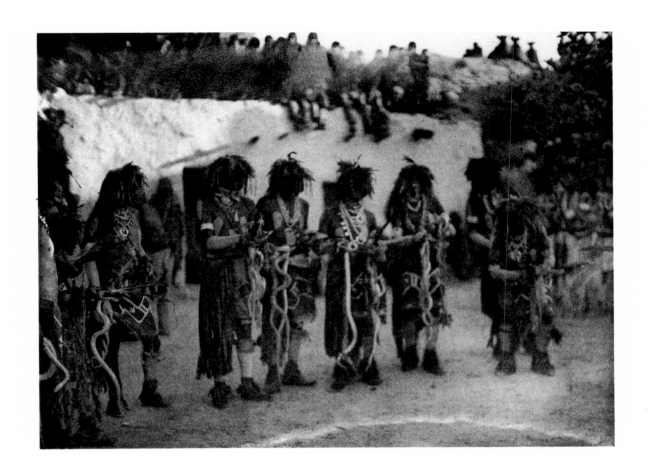

DEPOSITING SNAKES IN THE CIRCLE OF MEAL - HOPI, 1906

The snake dancers enter the plaza, encircle it four times with military tread, and then, after a series of songs remarkable for their irresistible movement, they proceed to dance with the reptiles.

WATCHING THE DANCERS - HOPI, 1906

A group of girls on the topmost roof of Walpi, looking down into the plaza. Picturesque Walpi, perched on the point of a rocky island in a sea of sand, is an irregular, rambling community, built without design, added to in haphazard fashion as need arose, yet constituting a perfectly satisfying artistic whole.

^I ZAHADOLZHÁ - NAVAHO, 1904

Fringe Mouth. There is no ascertainable significance other than that these spirits, whose abode is in the water, are supposed to have peculiar markings about their mouths. Rescue from drowning invariably redounds to the glory of these gods.

^{II} TOBAZĬSCHĬNI - NAVAHO, 1904

Born from Water. The second of the twin miracle-performing sons of the Virgin, Yólkai Estsán, White-Shell Woman. Man-destroying monsters, symbolic of earthly evils, infested the earth until destroyed by Tobazĭschĭni and his brother Nayĕnĕzganī.

^{III} HASCHĔZHĬNĬ - NAVAHO, 1904

Black God, the God of Fire. An important deity of the Navaho, but appearing infrequently in their mythology and ceremonies.

^{IV} GÁ᷾ASKĬDĬ - NAVAHO, 1904

The God of Harvest, a hunchback who carries seeds of the field in a pack on his back.

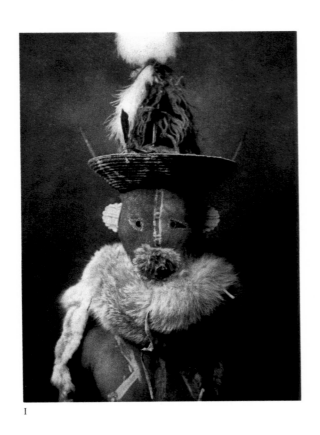

I

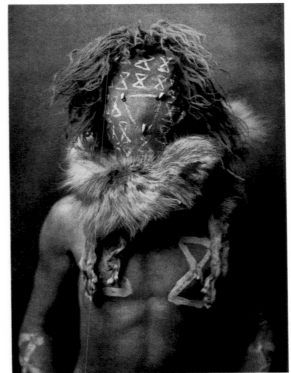

II

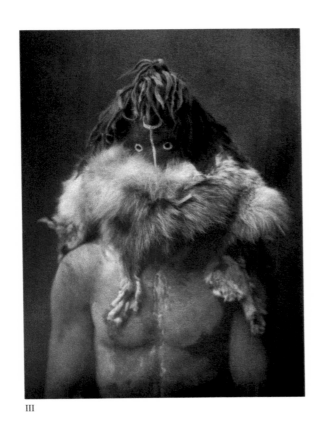

III

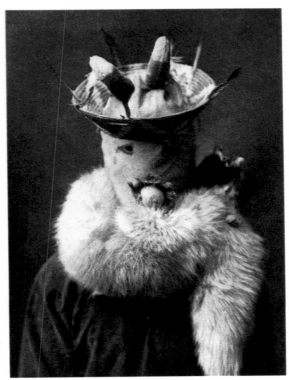

IV

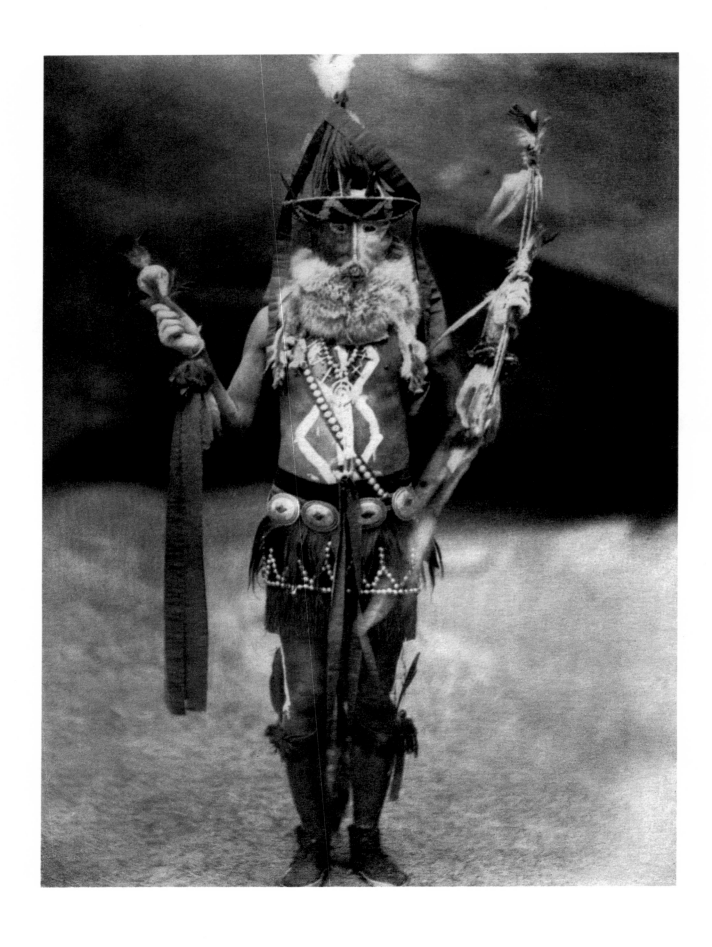

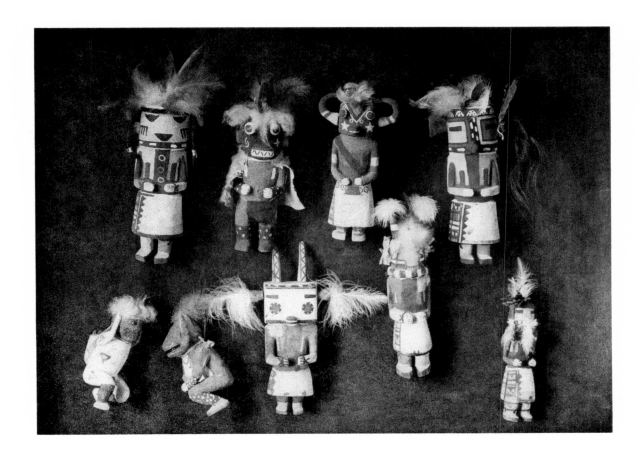

KACHINA DOLLS - HOPI, 1921

Effigies representing the Kachinas, the supernatural, anthropomorphic beings inhabiting the water-world that underlies the earth. The Hopi conception is that all bodies of water are parts of one great ocean underlying the earth, in other words, mere openings through the earth crust into the water-world.

ZAHADOLZHÁ -NAVAHO, 1904

Fringe Mouth standing. This deific character in Navaho mythology, though always beneficent, has no special functions to perform.

A HOPI MAN, 1921

In this physiognomy we read the dominant traits of Hopi character. The eyes speak of wariness, if not downright distrust. The mouth shows great possibilities of unyielding stubborness. Yet somewhere in this face lurks an expression of masked warmheartedness and humanity.

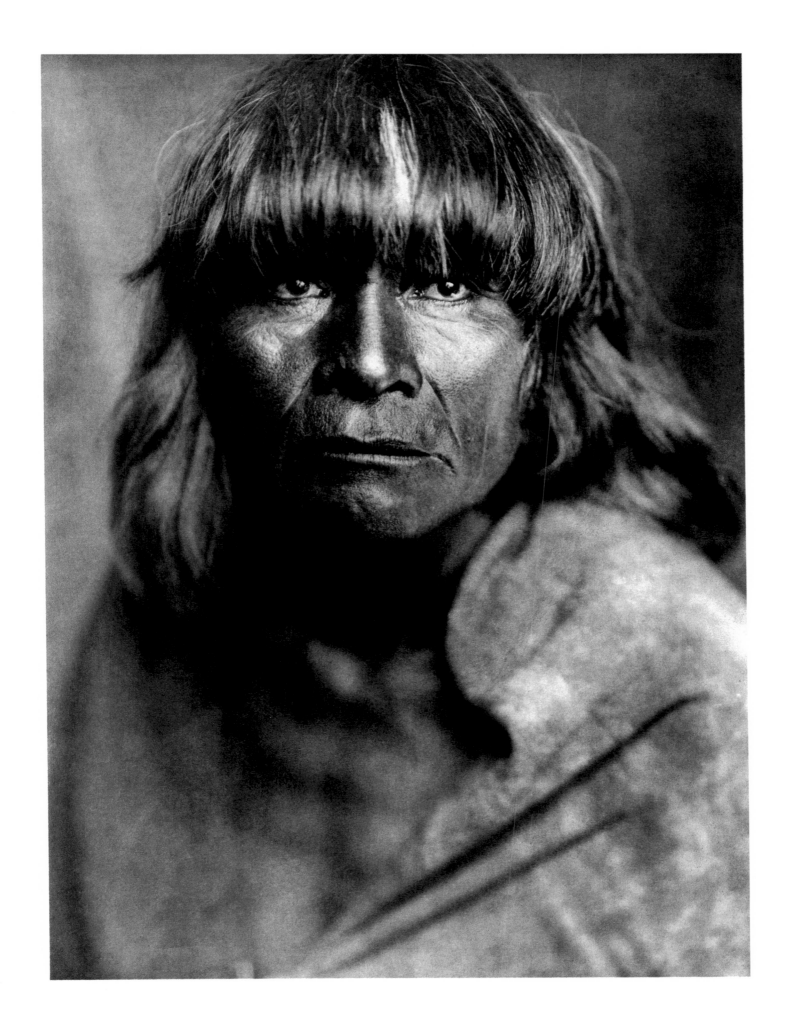

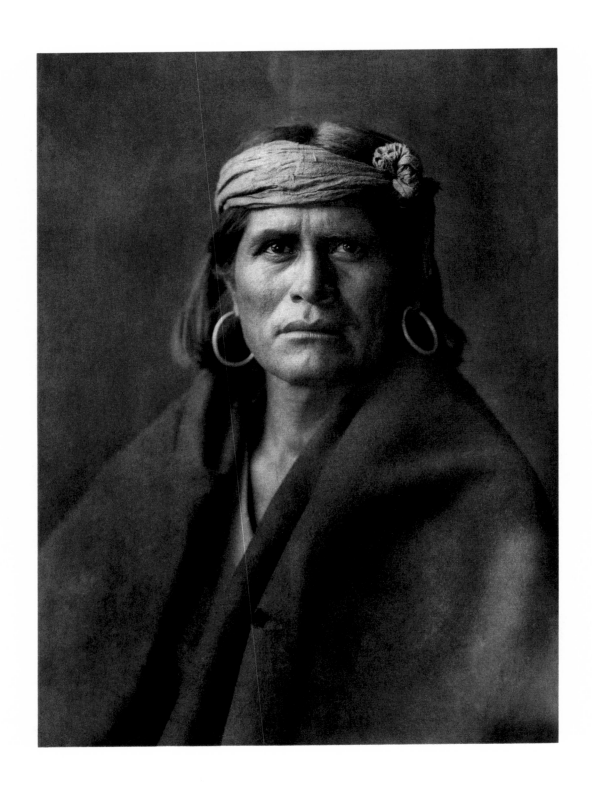

A WALPI MAN- HOPI, 1921

Walpi is the the best-known of Hopi villages. Certainly no other place in the United States afforded a like opportunity to observe native Americans living much as they did when the Spanish explorers first visited the desert land of our Southwest.

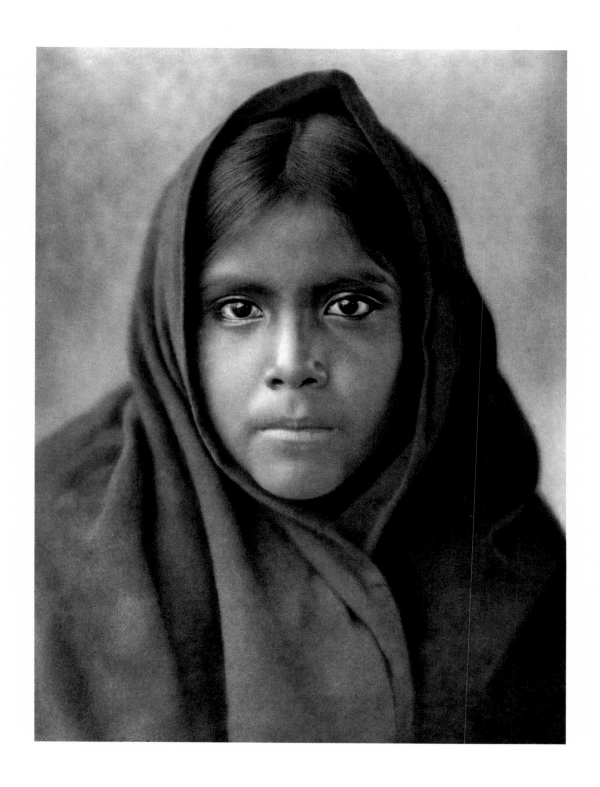

QAHÁTĬKA GIRL, 1907

About forty miles due south of the Pima reservation, in five small villages, one sees a type of the true desert Indian – the Qahátĭka. One traversing this region would have cause to wonder how a human being could wrest from so barren a land the necessities of life. When asked why they do not go to river valleys, where they might have good farms and live in plenty, their answer is that their home is the best; that they do not have the river sickness as do the River Indians.

A FEAST DAY AT ACOMA, 1904

Franciscan missionaries early in the seventeenth century introduced certain public Christian rites among the Pueblos, which ever since have been performed, with an intermingling of native ceremonial practices, especially on the days of the saints to whose protection the villages were respectively assigned. The day of San Estevan, patron saint of Acoma, is September second.

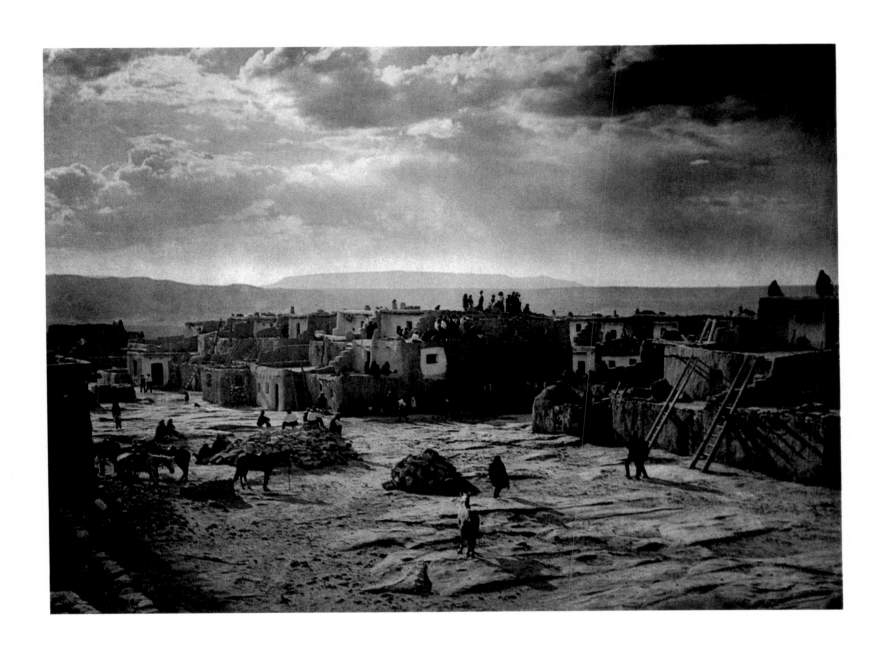

SIA STREET SCENE, 1925

Sia is situated on the north bank of Rio Jemez, a few miles below Jemez pueblo. Ancient Sia, having participated in the revolt of 1680, was completely destroyed and a large number of its inhabitants were killed by Governor Domingo de Cruzate in 1689. The pueblo was rebuilt, probably nearly on the same site, and during the remaining years of this troubled period Sia remained actively friendly with the Spaniards. Once a populous center, it housed only one hundred and fifty-four persons in 1924.

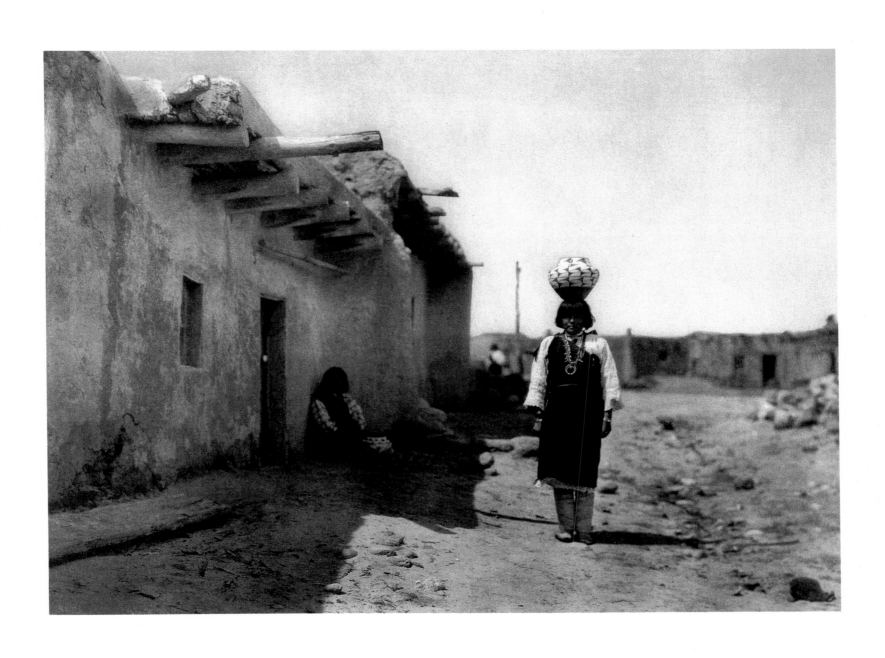

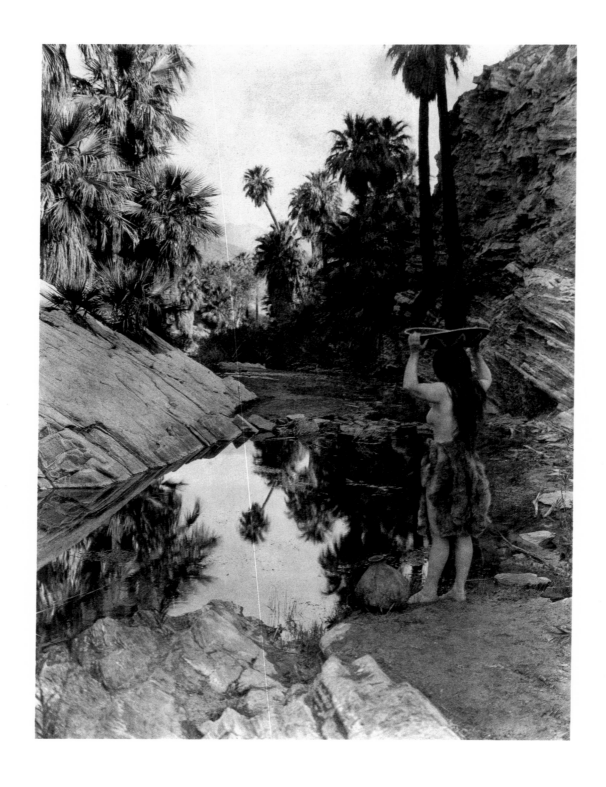

BEFORE THE WHITE MAN CAME - PALM CAÑON, 1924

Palm Cañon is at the eastern base of San Jacinto Mountain on Agua Caliente Reservation, which is one of several areas occupied by Cahuilla. The locality is well known under the name of Palm Springs.

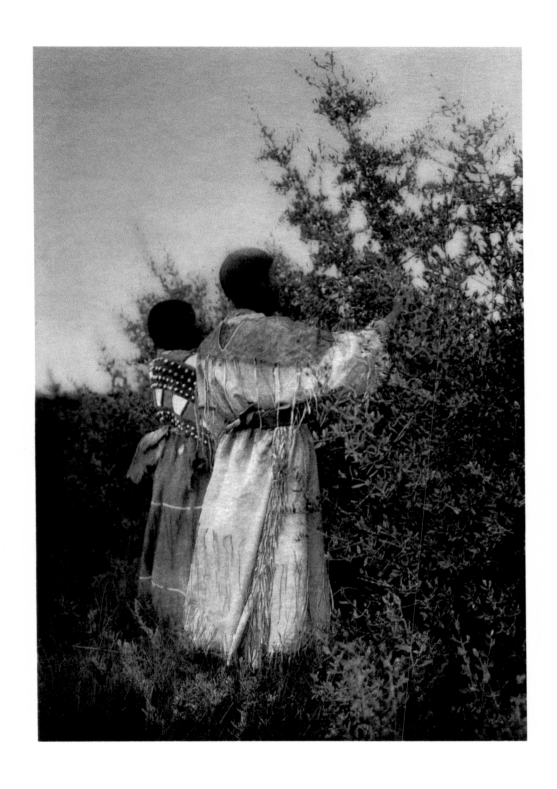

BUFFALO-BERRY GATHERERS · MANDAN, 1908

When observed by Lewis and Clark, the Mandan of Heart River, North Dakota, considering their numbers, were a vigorous people, of splendid physique, living in lodges that were not only spacious but provided with comforts unknown to the roving tribes, and growing crops ample for their immediate needs and affording a surplus for barter. Like all their neighbors, they depended chiefly on the buffalo for meat supply.

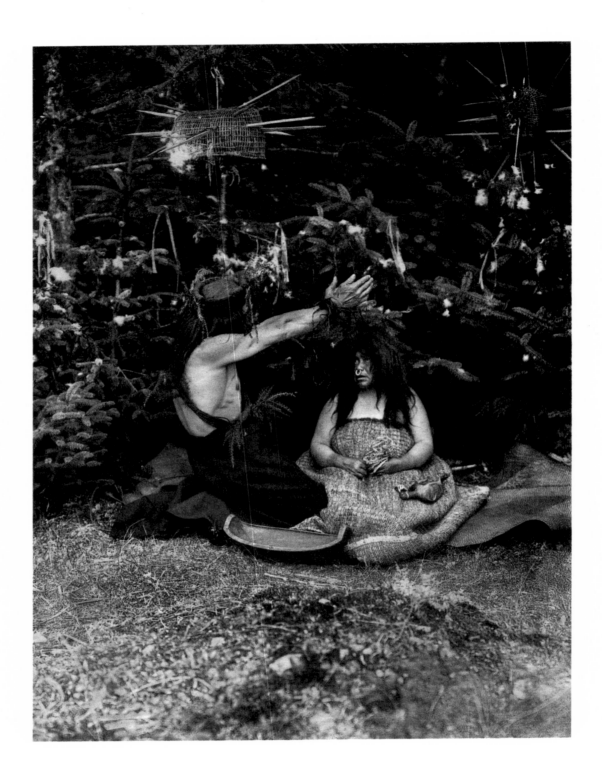

TWIN CHILD HEALER - KWAKIUTL, 1914

Twins are believed to come from the salmon, and when a twin child has a pain in the head, it is thought that the salmon are the cause. The illustration shows a twin child healer treating a twin child patient in a spruce booth in the forest. White eagle feathers are suspended from the line, and sharp sticks thrust through the baskets are for the purpose of destroying the life of the evil things that are persecuting the patient. It is possible that the sharp sticks have been borrowed from Asiatics within recent years.

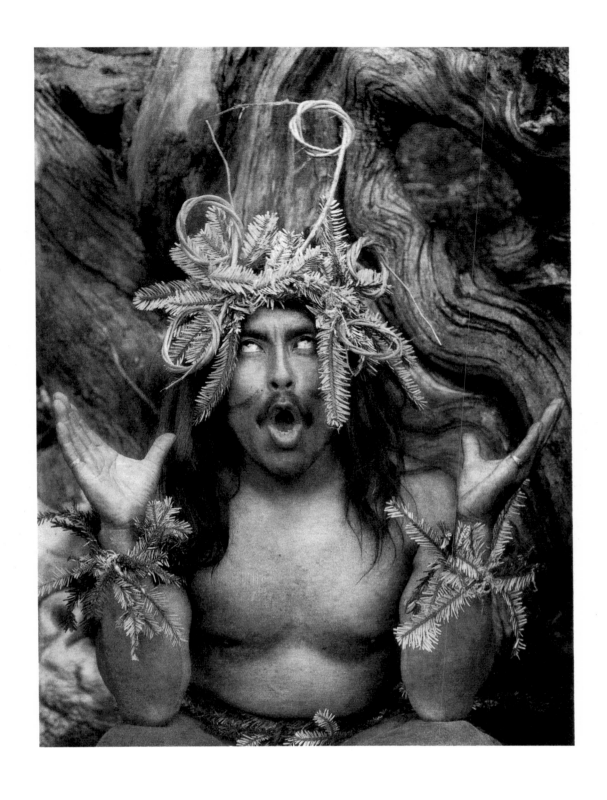

HAMATSA EMERGING FROM THE WOODS - KOSKIMO, 1914

The hamatsas – male performers in the Kwakiutl winter dances – are supposed to eat human flesh as a ceremonial rite.

A HAIDA SHAMAN'S RATTLE - HAIDA, 1915

The Haida are a group of closely related village communities inhabiting the Queen Charlotte Islands in British Columbia and the south end of Prince of Wales Island in Alaska Shamans were believed to be able to inflict fatal sickness on their enemies, and to cause death by apparent accident as by drowning. They frequently employed their supposed gift of prophecy, and they sometimes held meetings to decide whether or not to kill by magic a suspected witch.

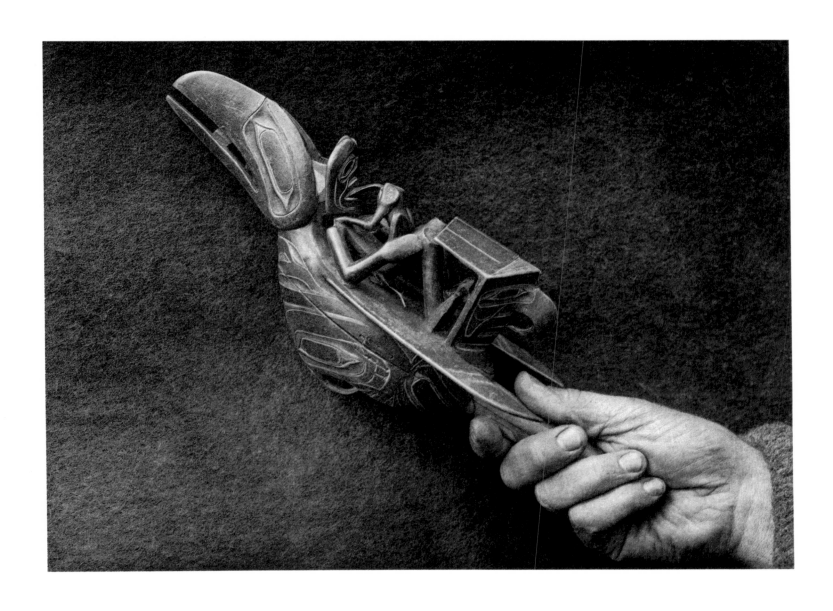

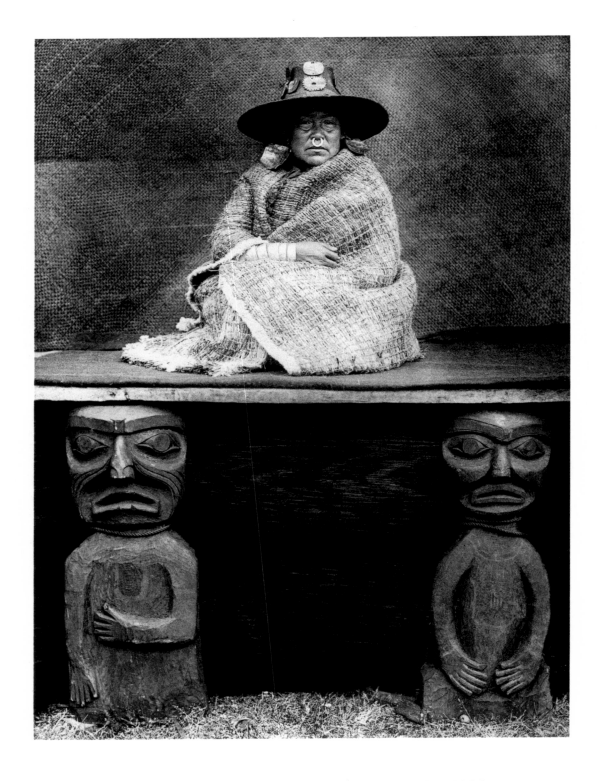

A NAKOAKTOK'S CHIEF'S DAUGHTER - NAKOAKTOK, 1914

When the head chief of the Nakoaktok holds a potlatch (a ceremonial distribution of property to all the people), his eldest daughter is thus enthroned, symbolically supported on the heads of her slaves.

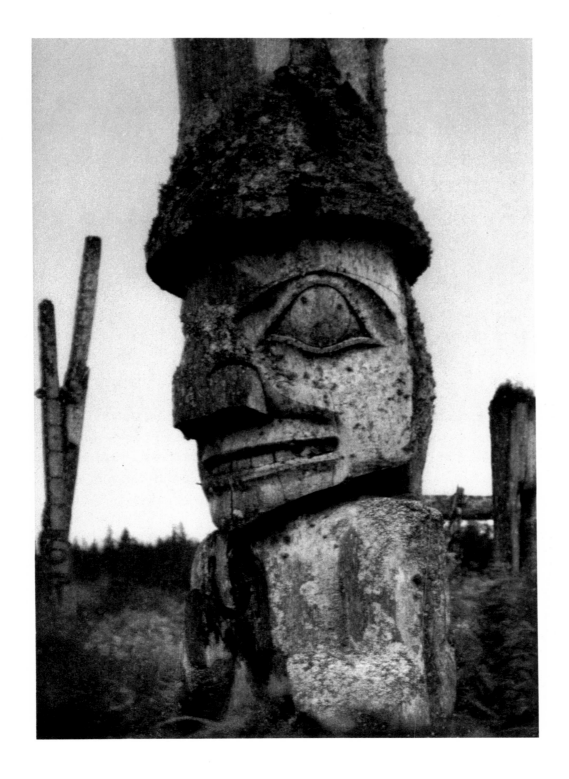

TOTEM AT YAN, REPRESENTING A CAUCASIAN -
HAIDA, 1915

The Haida came into contact with the white man as early as the late-eighteenth century. The Haida more than any other Indian tribe, it seemed, were quick to embrace the opportunities of civilization that the increasing numbers of explorers and traders who visited their territory represented. The open-armed acceptance by the Haida of the white man's world was such that most members of the tribe spoke enough English to conduct business transactions. Furthermore, the tribe replaced the white man's individualistic approach to running society for the inherited communism that they had known. This change was greatly beneficial to the tribe, making the society as a whole more ambitious, industrious and provident.

RED CLOUD - OGLALA, 1905

Born 1822. At the age of fifteen he accompanied a war party which killed eighty Pawnee. He took two scalps and shot one man. At seventeen he led a party that killed eight of the same tribe. During his career he killed two Shoshoni and ten Apsaroke. Once going against the Apsaroke, he left the party and approached the camp on foot. About daylight a man came driving his herd on the range. Red Cloud charged him, killed him with arrows, stabbed him with Apsaroke's own knife, and scalped him; he then took his clothes and started back, driving the horses. Men from the camp pursued, and a severe fight followed between the two parties. Once an Apsaroke captured his herd. He followed all night, and at daylight caught up with and killed the raider. Red Cloud received his name, in recognition of his bravery, from his father after the latter's death. Before that his name had been Two Arrows, Wa-no-pa. His brother-in-law, Nachili, gave him medicine tied up in a little deerskin bag. Always before going to war Red Cloud rubbed this over his body. All the tribe regarded his medicine as very potent. He first gained notice as a leader by his success at Fort Phil Kearny. Red Cloud was prevented from joining in the Custer fight by the action of General Mackenzie in disarming him and his camp.

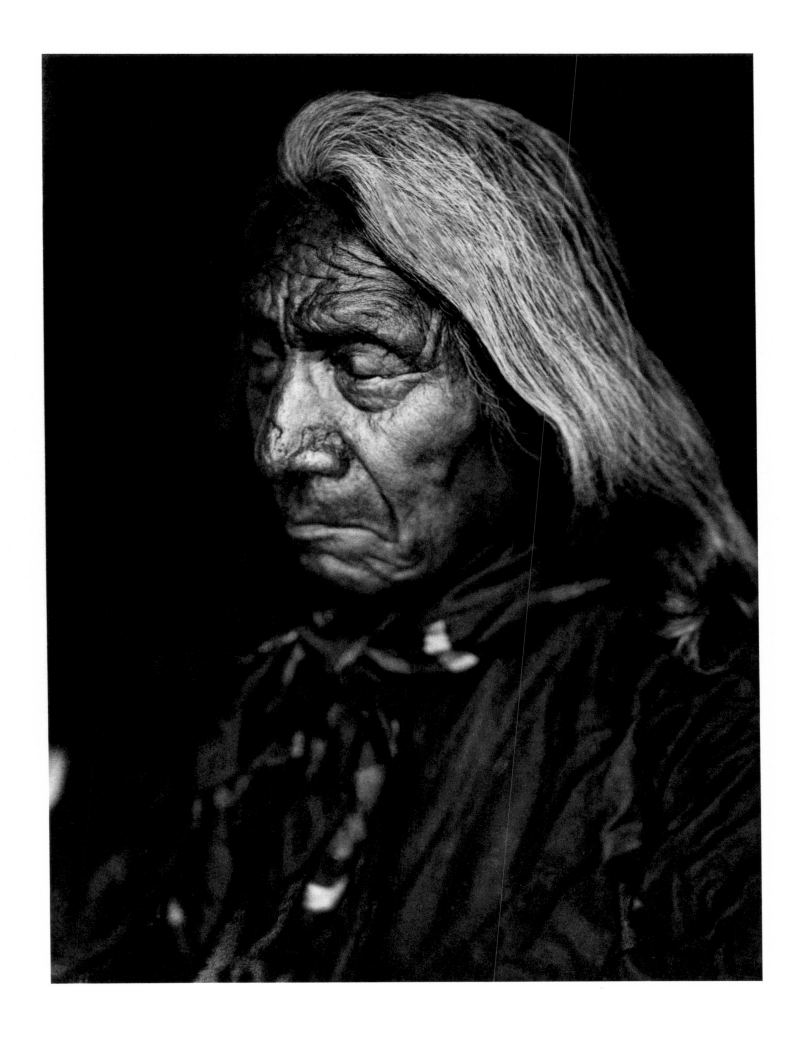

SLOW BULL - OGLALA, 1907

Born 1844. First war party at fourteen, under Red Cloud, against Apsaroke. Engaged in fifty-five battles with Apsaroke, Shoshoni, Ute, Pawnee, Blackfeet, and Kutenai. Struck seven first coups. At seventeen, he captured one hundred and seventy horses from Apsaroke. In the same year he received medicine from buffalo in a dream while he slept on a hilltop, not fasting, but resting from travel on the warpath. Counted two honors in one fight, when the Lakota charged an Apsaroke camp and were routed. Slow Bull returned to the enemy; his horse stepped into a hole and fell, and an Apsaroke leaped on him. He threw his antagonist off, jumped on his horse, and struck his enemy in the face with his bow. At that moment another Apsaroke dashed up and dealt him a glancing blow in the back with a hatchet. Slow Bull counted coup on him also. He has been a subchief of the Oglala since 1878.

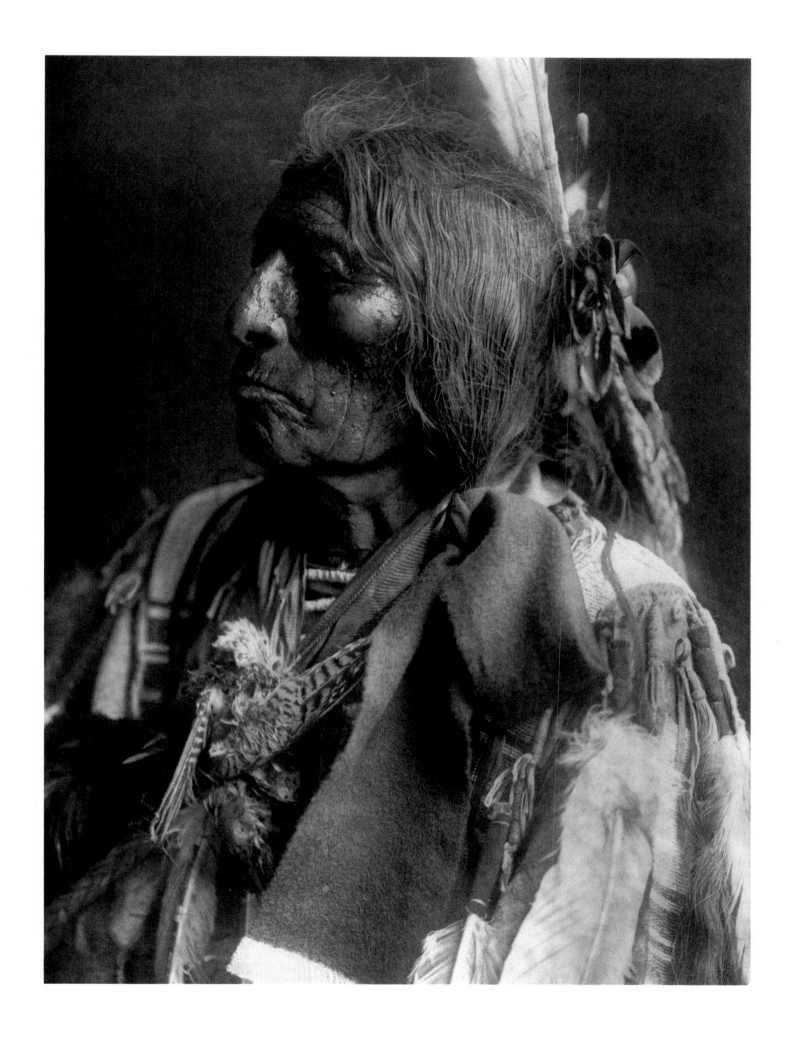

PLACATING THE SPIRIT OF THE SLAIN EAGLE - ASSINIBOIN, 1926

For their feathers, which were used in many ways as ornaments and fetishes, eagles were caught by a hunter concealed in a brush-covered pit. A rather elaborate ceremony took place over the bodies of the slain birds for the purpose of placating the eagle spirits.

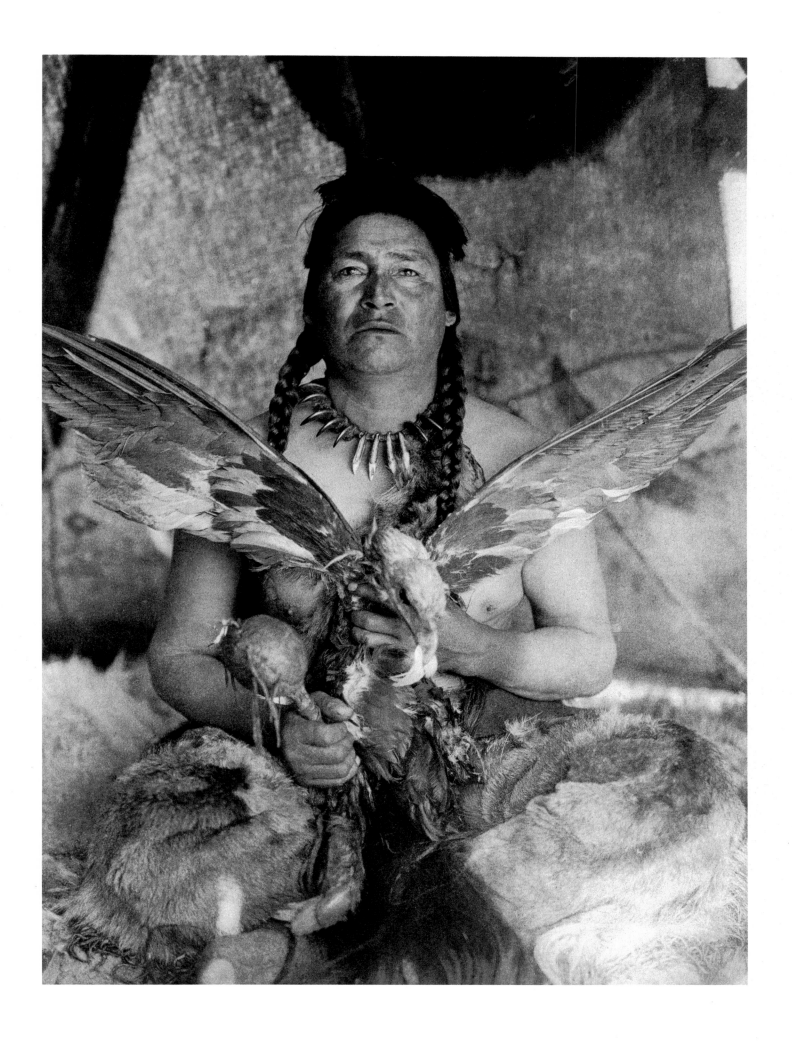

OFFERING TO THE SUN - SAN ILDEFONSO, 1925

A pinch of cornmeal tossed into the air as an offering to the numerous deities of the Tewa, but especially to the sun, is a formality that begins the day and precedes innumerable acts of the most commonplace nature.

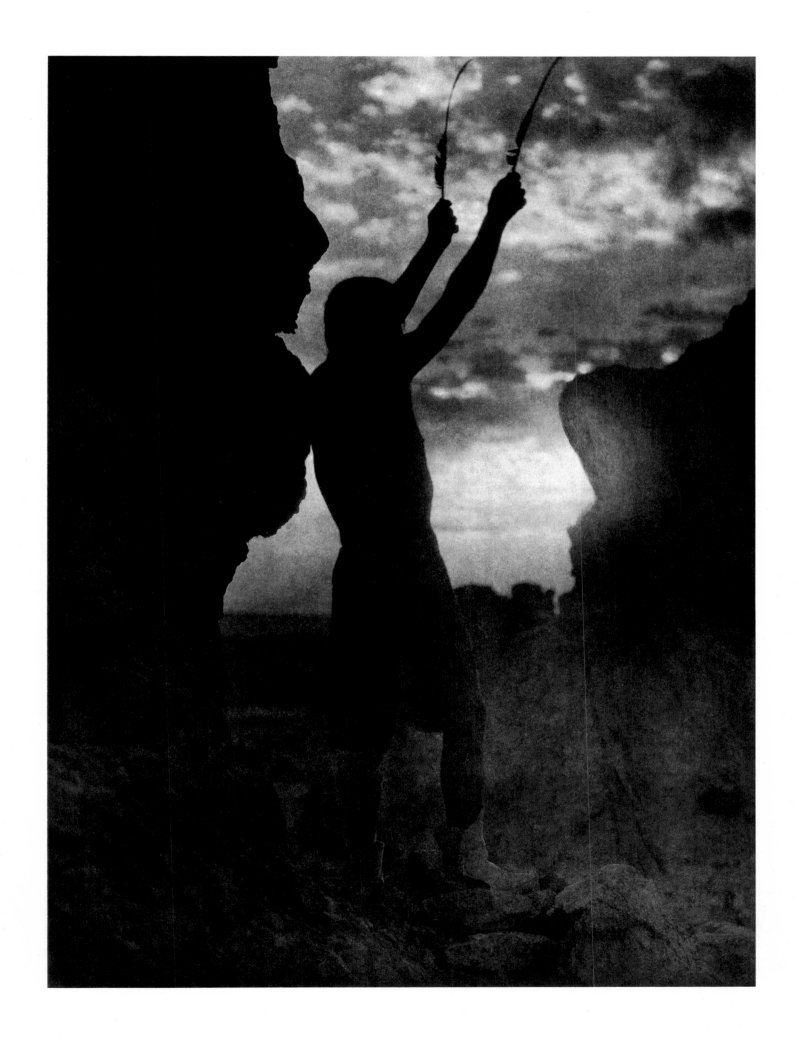

Selected Bibliography

Boesen, Victor, and Graybill, Florence Curtis. *Edward S. Curtis: Photographer of the North American Indian*. New York: Dodd, Mead and Co., 1977.

Coleman, A.D., and McLuhan, T. C. "Curtis: His Work." Introduction to *Portraits from the North American Indian by Edward S. Curtis*. New York: Dutton, 1972.

Curtis, Edward Sheriff. "The Rush to the Klondike Over The Mountain Passes." *Century Magazine*, March 1898, 692.

————· "Photography." *Western Trail*, January 1900, 186-88. Pacific Northwest Collection.

————· "The Amateur Photographer." *Western Trail*, February 1900, 272-74. Pacific Northwest Collection.

————· "The Amateur Photographer." *Western Trail*, April 1900, 379-80. Pacific Northwest Collection.

————· "The Amateur Photographer." *Western Trail*, May 1900, 468-69. Pacific Northwest Collection.

————· "Vanishing Indian Types: Tribes of the Southwest." *Scribner's Magazine*, May 1906, 513-29.

————· "Vanishing Indian Types: The Tribes of the Northwest Plains." *Scribner's Magazine*, June 1906, 651-71.

————· "Indians of the Stone Houses." *Scribner's Magazine*, February 1909, 161-75.

————· "Village Types of the Desert Land." *Scribner's Magazine*, March 1909, 275-87.

————· *The North American Indian*. 20 volumes. Vols. 1-5, Cambridge, Mass.: The University Press. Vols. 6-20, Norwood, Conn.: Plimpton Press. 1907-30. New York and London: Johnson Reprint Corp., 1970.

1907	Volume 1-Apache, Jicarilla Apache, Navaho
1908	Volume 2-Pima, Papago, Qahatika, Mohave, Yuma, Maricopa, Havasupai, Apache-Mohave
1908	Volume 3-Teton Sioux, Yanktonai, Assiniboin
1909	Volume 4-Apsaroke, Hidatsa
1909	Volume 5-Mandan, Arikara, Atsina
1911	Volume 6-Piegan, Cheyenne, Arapaho
1911	Volume 7-Yakima, Klickitat, Interior Salish, Kutenai
1911	Volume 8-Nez Percé, Walla Walla, Umatilla, Cayuse, Chinookan
1913	Volume 9-Coast Salish, Chimakum, Quilliute, Willipa
1915	Volume 10-Kwakiutl
1916	Volume 11-Nootka, Haida
1922	Volume 12-Hopi
1924	Volume 13-Hupa, Yurok, Karok, Wiyot, Tolowa, Tututni, Shasta, Achomawi, Klamath
1924	Volume 14-Kato, Wailaki, Yuki, Pomo, Wintun, Maidu, Miwok, Yokuts
1926	Volume 15-Southern California Shoshoneans, Diegueños, Plateau Shoshoneans, Washo
1926	Volume 16-Tiwa, Keres
1926	Volume 17-Tewa, Zuni
1928	Volume 18-Chipewyan, Cree, Sarsi
1930	Volume 19-Wichita, Southern Cheyenne, Oto, Commanche
1930	Volume 20-Nunivak, King Island, Little Diomede Island, Cape Prince of Wales, Kotzebue

————· *Indian Days of Long Ago*. Yonkers-on-Hudson, New York: World Book Co., 1914. Reprint. Berkeley: Ten Speed/Tamarack Press, 1975.

————· *In the Land of the Headhunters*. Yonkers-on-Hudson, New York: World Book Co., 1915. Reprint. Berkeley: Ten Speed/Tamarack Press, 1975.

Davis, Barbara. *Edward S. Curtis: The Life and Times of a Shadow Catcher*. San Francisco: Chronicle Books, 1985.

Gidley, Mick. *The Vanishing Race: Selections from Edward S. Curtis's "The North American Indian."* London: David and Charles; New York: Taplinger Publishing, 1977.

————• "Edward S. Curtis Speaks…" *History of Photography*, October 1978, 347-54.

————• "From the Hopi Snake Dance to the 'Ten Commandments': Edward S. Curtis as Filmmaker." *Studies in Visual Communication,* Summer 1982. 70-79.

————• "A. C. Haddon Joins Edward S. Curtis: An English Anthropologist Among the Blackfeet." *Montana, the Magazine of Western History*, Autumn 1982, 21-33.

Goetzmann, William H., and Sloan, Kay. *Looking Far North: The Harriman Expedition to Alaska*. Princeton: Princeton University Press, 1982.

Graybill, Florence Curtis, and Boesen, Victor. *Edward Sheriff Curtis: Visions of a Vanishing Race*. New York: Thomas Y. Crowell, 1976.

Hartmann, Sadakichi. "E. S. Curtis, Photo Historian." In *The Valiant Knights of Daguerre*. Berkeley and Los Angeles: University of California Press, 1982.

Holm, Bill. *"The Vanishing Race and Other Illusions: Photographs by Edward S. Curtis* by Christopher M. Lyman." *American Indian Art Magazine*, Summer 1983, 68-73.

Holm, Bill, and Quimby, George Irving. *Edward S. Curtis in the Land of the War Canoes: A Pioneer Cinematographer in the Pacific Northwest*. Seattle: University of Washington Press, 1980.

Lee, William Beachum. *The Nature of Reality in Ethnographic Film: A Study Based on the Work of Edward S. Curtis*. Ann Arbor, Michigan: University Microfilms, 1980.

Lyman, Christopher M. *The Vanishing Race and Other Illusions: Photographs by Edward S. Curtis*. New York: Pantheon Books in association with the Smithsonian Press, 1982.

Marshall, Edward. "The Vanishing Red Man." *Hampton Magazine*, May 1912, 1004-11.

Rice, Leland. *Edward S. Curtis: The Kwakiutl, 1920-1914*. Irvine: University of California, 1976.

Nicholas Callaway, Editorial Director
Charles Melcher, Publisher
Antoinette White, Editor • Brian Wu & Toshiya Masuda, Designers • True Sims, Production Director
Ivan Wong, Jr., Production Associate • Kyoko Tateno, Design Associate
Patti Richards, Publicist • Anne Simmons, Sales Associate
Monica Moran, Jose Rodriguez, Sophia Seidner, Meredith Ward and Thomas West
assisted in all aspects of the publication

And with thanks to Barbara Davis, James Flury, Robert Gilnick, Robert Kapoun,
Marc Sandhaus, Andrew Smith and especially Kit Wilson

Type was composed with QuarkXPress software for Macintosh by Toshiya Masuda,
using the Trajan and Meridien typefaces from Adobe Systems.

The original artwork was photographed as 4" x 5" color transparencies and scanned in to the Agfa PIX System with an
Optronics ColorGetter™ drum laser scanner. The film was then separated using the Agfa SelectSet 5000 imagesetter.

The separation of the film was carried out by Richard Benson using Agfa CristalRaster™ technology.
Unlike conventional halftone dot generation, where the dots vary in size and are arranged precisely on a grid pattern,
CristalRaster™ uses "calculated randomness".
Also known as frequency modulation, this technology generates uniformly-sized microdots representative of the
tonal values being reproduced. With this method, dot placement, and therefore tone, is based on adjusting the
space between dots rather than on the size of the dots. As a result of this random calculation without screens, visual
obstructions, from moiré and rosette patterns, which are inherent to conventional halftone-printing are eliminated, and
near continuous-tone imagery and ultra-fine resolution are produced.

Richard Benson also created, especially for this book, a quadratone printing technique:
four layers of ink from four different films laid down in varying shades of black, grey and sepia
on uncoated paper to best interpret the long tonal scale, warm color and texture of Curtis's original flat-plate gravures.

The book was printed and bound by Heritage Press in Dallas, Texas,
under the supervision of Richard Benson and Nicholas Callaway.
Jarmon Downs represented Heritage Press. The paper is Mohawk Vellum
from Mohawk Paper Mills, Inc., Cohoes, New York.

The equipment used to create the images was supplied by Agfa Division of Miles, Inc.,
Wilmington, Massachusetts and Optronics, an Intergraph Division, Chelmsford, Massachusetts.
Callaway appreciates the generosity of these organizations for sharing their knowledge and assistance.
Special acknowledgement goes to Peter Broderick, Cynthia Hollandsworth,
Marion Mathison and Dr. Jerry Stolt of Agfa, to Edward T. Chrusciel of Optronics, as well as to
Ted and Tom O'Conner and Laura Shore of Mohawk Paper Mills, Inc.